IMAGES
of America

AVONDALE ESTATES

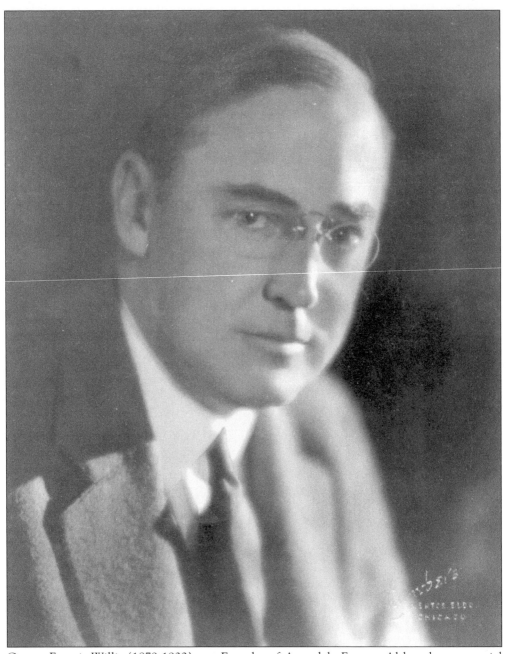

George Francis Willis (1879-1932) was Founder of Avondale Estates. Although commercial success brought Mr. Willis international fame and fortune, the heart of the man is found in the ends to which he devoted his wealth. As founder of a city unique in America, he put not only his money and remarkable business talent into the historic town, but also his high ideals. Into Avondale Estates, he poured "[h]is love of beauty, his sense of patriotism, his human kindness, his unpretentious, but deep-seated desire to add to the world's happiness and to his community's enrichment in things that make life worth living." (Courtesy Special Collections Department, Robert W. Woodruff Library, Emory University.)

IMAGES
of America

AVONDALE ESTATES

Terry Martin-Hart

ARCADIA

Published by Arcadia Publishing,
an imprint of Tempus Publishing, Inc.
2 Cumberland Street
Charleston, SC 29401

Printed in Great Britain.

Library of Congress Catalog Card Number applied for.

For all general information contact Arcadia Publishing at:
Telephone 843-853-2070
Fax 843-853-0044
E-Mail arcadia@charleston.net

For customer service and orders:
Toll-Free 1-888-313-BOOK

Visit us on the internet at http://www.arcadiaimages.com

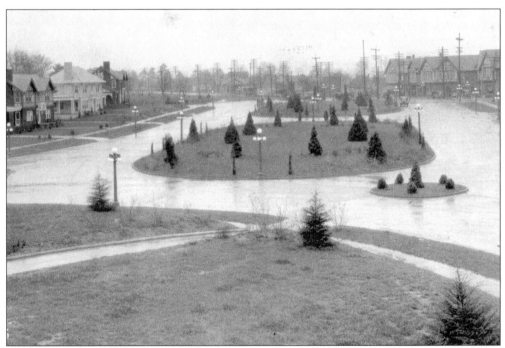

The historic commercial, residential, and landscape features of Avondale Estates are showcased in this sweeping view of Avondale Plaza. By 1926, George F. Willis had completed the Tudor Revival-style commercial buildings, featuring multiple gables, half-timbering, and picturesque roofline. Fitting in with the city's English village theme, many of the historic houses of Avondale Estates were designed with medieval English references. The houses shown to the left are among the original seven built on Avondale's main plaza. (Courtesy Tom Forkner.)

CONTENTS

East and west entrances to the City of Avondale Estates feature welcome signs. In the 1980s, when the city was placed on the National Register of Historic Places, the above sign was removed and a gilded one, depicting the English Village, was introduced. (Courtesy Avondale Estates Garden Club.)

INTRODUCTION

Avondale Estates

On the National Register of Historic Places

In the 1920s, Avondale Estates was described as an oasis, situated high upon rolling hills, with "all the best" that life had to offer. The English Village was "far removed from the noise and dirt" of the city. A ride into Atlanta on a horse-drawn buggy or wagon was a two-day trip or about 30 minutes by streetcar. In fact, Avondale Estates is only seven miles from Atlanta, but rises 52 feet above it. In the early days, the massive granite rock of Stone Mountain could be clearly seen in the distance. When Avondale Estates was named on the National Register of Historic Places in the 1980s, it was found to be the only documented example of a "planned new town" in Georgia and the Southeast.

Self-made millionaire George Francis Willis founded Avondale Estates in 1924. A native of North Carolina, Willis and his partner, McDuffie, worked from an office in the old First National Bank Building at Peachtree and Marietta Streets, and made a fortune in patent medicines. Willis, however, saw his future in real estate. One afternoon, while en route to Stone Mountain from his majestic home in Druid Hills, he discovered the pastoral farmland of Ingleside. He quickly seized upon the opportunity to transform Ingleside, and 950 acres of

adjoining land, into "the seat of an ideally perfect social and political life." For the remaining years of George Willis' life, Avondale Estates took precedence over all his other business ventures.

Sparing no expense, he hired civic engineers, landscape architects, and city planning authorities of international renown. The major portion of credit belongs to his core staff of men, including O. F. Kauffman, chief engineer; W.E. Bedinger, Kauffman Engineering staff; Robert B. Cridland, landscape architect from Philadelphia; J.G. Hardeman, landscape gardener; E. M. Moffett, secretary to Willis; and Ben S. Forkner, General Manager and Superintendent. In 1926, Willis commissioned famed artist and Civil War historian, Wilbur G. Kurtz, to paint an image of the ideally perfect city as Willis had imagined it. Wilbur Kurtz' rendering hangs on the walls of the City Hall to this day.

From the beginning, Willis intended that Avondale Estates would be an independent city with its own government. In August of 1926, the city charter (closely patterned after the 1917 charter used at Kingsport, Tennessee) was approved by the state legislature. On January 1, 1928, it became effective when adopted by the community in a referendum. The fact that the city was incorporated is unique in the history of early-20th-century suburban developments in Atlanta. Since its incorporation, government leaders and community-spirited citizens have worked together to maintain the city's ambience.

By the end of 1926, Willis had built his ideal city on the site of an ancient crossroads of wooden buildings. Presented as the realization of a dream, he constructed an English Tudor-style row of commercial buildings. Designed by prominent early-20th-century Atlanta architect, Arthur Neal Robinson, they are Georgia's only examples of the fully developed Tudor Revival style. The English Village stands today virtually as it did in the 1920s, with only minor changes. This architectural style, inspired while Mr. Willis and his wife, "Lottie," were visiting Stratford-Upon-Avon in England, would dominate the City of Avondale Estates and serve as its gateway into history.

In a setting of shade trees, Willis Park was added, complete with private pool, clubhouse, tennis courts, playground, and playing fields. In fact, Willis had several parks in mind for Avondale Estates. One afternoon in the mid-1920s, while standing on the front porch of a large, two-story home owned by the Harrell family, Willis looked to the south and envisioned a body of water: "Inviting the swimmer, the fisherman and the boating devotee." Lake Avondale was soon dug out and filled with spring-fed water by damming Cobb Creek at Wiltshire Drive. The lake was gracefully landscaped with a terraced 10-foot wide bridle path, a boat-and-bath house (the present day Community Club), and a beach. Truckloads of sand were continuously deposited along the banks. The idea for a beach was finally abandoned, however, as the sand kept sinking. Later on, the lake was stocked with fish and ducks.

In those early days, many residents owned horses. For those that didn't, however, there was the Avondale Riding Stable. Golf, on Forrest Hills Course and prestigious Ingleside Country Club (now the American Legion), helped complete the ideal town. Shortly after Willis purchased the property, he donated three acres for new schools. The educational facilities for children were enhanced by the city's numerous parks and playgrounds, with "every known help to healthful play." A local dairy farm boasting "thirty splendid Jersey cows" provided "only the purest milk and cream" to the rosy-cheeked residents. A large nursery and vegetable garden was within easy access for purchase and free delivery of flowers, shrubs, trees, and fresh vegetables.

By 1926, about fifty model homes had been completed to the last detail and were ready for show. The historic homes were built in the Tudor Revival and English Cottage style, with stone-trimmed porches and doorways. Dutch Colonial, Bungalow, and Spanish Mission-style homes were also built during that time. Many houses featured garages, which some residents used to shelter their horses. The garages varied from crude, wood-framed boxes to impressive structures that repeated the architecture of the house.

Beautiful exteriors called for equally beautiful furnishings, and again Willis spared no expense. Publicity and advertising, from awnings to automobiles, was at an all-time high.

People came from all parts of the country to Avondale Estates. Some achieved local or even national celebrity, such as Marion Reinhardt, former Rockette and professional dancer for half a century; Guy Hayes, 50-year photographer for the *Atlanta Journal and Constitution*; Robert H. Farrar, Georgia State Senator; James Livingstone, Ingleside Country Club's Scottish-born pro golfer for whom a street was named; "Whispering" Bill Anderson, recording and television artist of Grand Old Opry fame; and Alton "Rocky" Adams, star athlete and professional Sprint car driver. Older residents recall that Hollywood star Dick Van Dyke made Avondale Estates his home for a while. A state historic marker in front of 10 Avondale Plaza honors Gutzon Borglum, who lived here during his initial carving of Stone Mountain. George Willis, future President of the Stone Mountain Confederate Memorial Association, offered the stately home to Borglum from 1923 to 1925 during his commission for the monumental carving.

In 1928, the media described Avondale Estates in this way: "So stupendous was the development program announced four years ago for Avondale Estates that it fairly staggered the imagination. Its ultimate completion was almost beyond belief, so gigantic it was. But it has been carried out in every detail." Another 75 houses were constructed before the Depression slowed development. By the summer of 1931, however, the Depression had taken its toll and Mr. Willis was forced to auction off hundreds of lots. An auction was held with "no price limit of any kind." A huge tent was set up along North Avondale Road, and property into which Mr. Willis had poured his personal fortune sold for as little as $50 per lot. In 1941, with the outbreak of World War II, development ceased, but it would resume again.

Avondale Estates, a bird sanctuary and home to one of the first Garden Clubs in Georgia, is beautifully landscaped in keeping with Willis' dream. In 1927, landscape artists designed a layout calling for 30,000 shrubs and trees. The city showcases an informal, but carefully planned historic style, mainly derived from 18th- and 19th-century English gardening. In the spring, plazas, parks, streets, and yards glow with color from ornamentals, such as the 14 miles of watermelon-pink crepe myrtle, dogwood, and redbud trees. Large magnolia, maple, oak, and pine provide shade. In the winter, a lofty holly tree on Clarendon is decorated with Christmas lights, a tradition since the 1930s. The most historic landscape feature, however, is the city's 1930's planting of a three-block long hedge of 253 abelia bushes, separating the commercial traffic corridor from the quiet residential area. Many of the landscape features in Avondale Estates were adopted from the works of Frederick Law Olmstead (of New York's Central Park and Atlanta's Druid Hills fame). The natural plantings of medians, traffic islands, parks, and streets combine to create the overall feeling of a Norman Rockwell painting having come to life in the City of Avondale Estates.

The images presented offer a glimpse into a past era, and are not meant to document all of the city's important people and events. They do, however, chronicle the profound mutual love of community and respect for wildlife that has molded Avondale Estates, and held fast to the dream of its Founder, George Francis Willis.

–TMH

One

THE EARLY HISTORY

FROM INGLESIDE TO AVONDALE ESTATES

"Faithful Cooperation Brings Mutual Success." George F. Willis

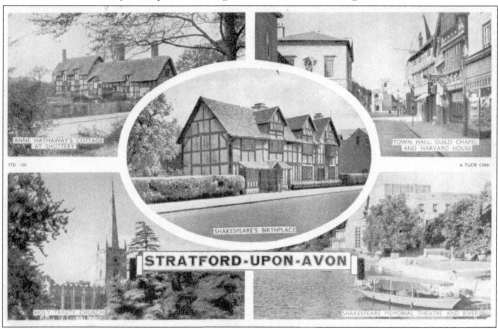

This 1920s postcard printed by Raphael Tuck & Sons, Ltd. depicts Stratford-Upon-Avon in England, the birthplace of William Shakespeare. After a vacation to Stratford-Upon-Avon, George Willis and his wife, Lottie, were inspired to recreate the Tudor Revival-style architecture, thereby christening the City of Avondale Estates with a noble namesake. The layout plan for Avondale Estates, designed by O.F. Kauffman, is patterned after Old Boston with street names such as Dartmouth, Exeter, Berkeley, Clarendon, and Wiltshire. In a letter to George Willis dated May 25,1926, Mr. Kauffman wrote, "You honored me with the opportunity to realize my cherished ambition as a specialist in land subdivision." (Courtesy Allan Kirwan.)

George F. Willis of Waynesville, North Carolina, married Charlotte "Lottie" McMichael Bowers of Richmond, Virginia, on February 17, 1904. Lottie was a member of one of Virginia's most prominent families, and highly touted as one of Richmond's beauties. The Willis' moved to Atlanta, where Lottie lived until her death in 1934, just two years after Mr. Willis passed away. Lottie was a distinguished member of Southern society, and well-known for her philanthropic work. (Courtesy George F. Willis, III.)

Three sons were born to George and Lottie Willis. They were George Francis Willis, Jr., John Bowers Willis, and Richard Bennett Willis. Here, young John Willis is photographed in the Willis rose garden. The Willis Estate was featured in a 1920s issue of *Country Homes* in which the author wrote, "the landscape architecture of the place so intimately reflects the character of the dwelling that each seems an inseparable part of the other." (Courtesy Marion Reinhardt.)

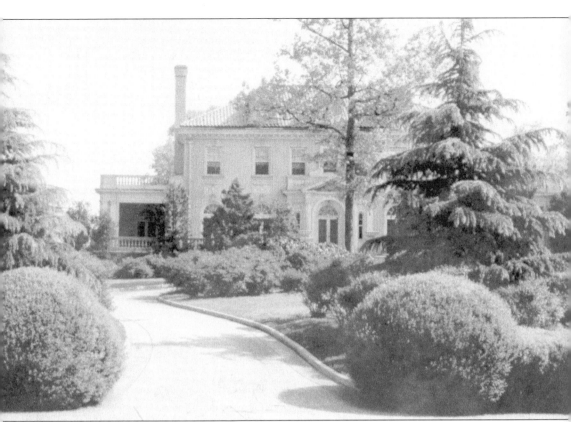

The Willis Estate, complete with tennis courts, included a beautifully landscaped plot of land 150 by 750 feet, and was located at the corner of Ponce de Leon and Clifton Road in Druid Hills. The Colonial home, built in 1918, was a commanding sight. Extending along the street façade several feet above the ground was a tile-paved terrace leading to the main hall. The entrance featured a fanlight of lead glass crowning double doors, framed by Tuscan pilasters and pediment. The effect was one of serene beauty and delicacy. Walls were paneled from floor to ceiling, and an imposing staircase was said to be so perfectly and realistically Colonial in appearance that it was impossible to consider it a reproduction. The living room featured beamed ceilings, and an impressive mantle with exquisitely carved Italian pilasters and tile fireplace beneath. "As soon as one enters the Willis home," *Country Homes* reported, "one instinctively recognizes that all is well with the entire house." The Willis Estate was acquired by Fernbank, and subsequently torn down in the mid-1970s to make way for the Natural History Museum. (Courtesy Marion Reinhardt.)

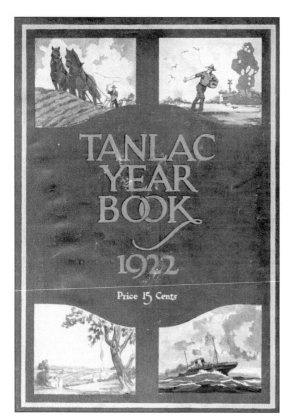

George F. Willis was an extraordinary salesman and promoter of proprietary medicines. In 1913, he founded International Proprietaries, Inc. Between 1913 and 1922, Willis made a fortune in Tanlac, and sold the company to S.A. Lynch for over one million dollars in 1922. According to the *Hearst's Sunday American*, George Willis was then the largest individual purchaser of advertising in the world. This photograph shows the cover of the first *Tanlac Year Book*. (Courtesy Allan Kirwan.)

Twenty-five million bottles of Tanlac were sold in a mere seven years, an average of one bottle for every family then living in the U.S. and Canada. After his success with Tanlac, Willis turned his attention to Zonite, an antiseptic preparation developed from the famous Dakin's solution, used in World War One. With Zonite, he made another fortune before selling his stock to the Huttons of New York. (Courtesy Allan Kirwan.)

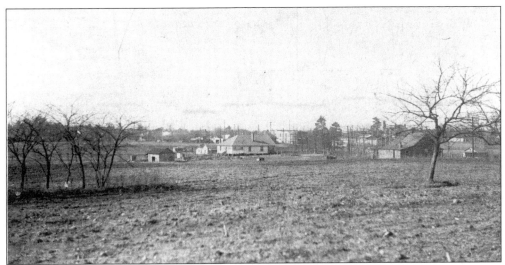

On January 19, 1924, newspapers announced that George F. Willis had purchased the town of Ingleside and an adjoining 950 acres of land, which he intended to develop into a model residential suburb. Ingleside, the name given the village by the Dabneys and Mr. Almond of Conyers, had been a United States post office since 1892. When Willis purchased Ingleside, several large farms and the small rural community occupied the land. (Courtesy Tom Forkner.)

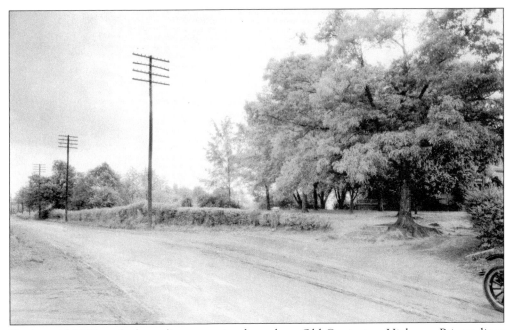

By the mid-1920s, telephone lines were in place along Old Covington Highway. Private lines were unheard of, and two or more party lines were the norm. Before the settlers arrived, Covington was a migration trail for the Cherokee Indians. Later, it became the old stagecoach route from Augusta to Nashville. Gypsies frequently camped and sold their wares along Covington, until they were banished from the city during the 1950s. (Courtesy Tom Forkner.)

Ben S. Forkner employed Jesse Solomon, who maintained the land behind the present-day elementary school, and later worked for Forkner Realty. Jesse and his wife, Pearl, lived on this farm on Covington Road in Ingleside. The drive from Atlanta to Ingleside was often taken for its scenic beauty. Jesse and Pearl parented 12 children, had 35 grandchildren, and 19 great-grandchildren. (Courtesy Tom Forkner.)

As the first step in his monumental development plan, Willis paid a half-million dollars for the huge acreage, which included the following tracts: Candler, 400 acres; Harrell, 35 acres; Forkner, 50 acres; Johnson, 116 acres; Ansley, 58 acres; Burgess, 60 acres; J.T. Freeman, 3 tracts, 26 acres; Van Valkenberg, 20 acres; Hill, 100 acres; Corley, 10 acres; Farrar, 4 acres; Campbell, 8 acres; Eldridge, 20 acres; Shumate, 31 acres; J.P. Freeman, 10 acres; and Owen's town lot. (Courtesy Tom Forkner.)

Judge John S. Candler's Mileybright Farm (above right) attracted statewide attention. His herd consisted of 80 full-bred Guernseys, many imported from the Isle of Guernsey. The premier cows had their own stalls and pastures, and were milked three times a day to increase production. Candler's modern barn was U-shaped, with cork floors. "A cow will have rheumatism just like a cook, if she has to stand on concrete," Judge Candler quipped. Judge Candler's farmhouse (shown below) is pictured to the far left in the above photograph. (Courtesy Tom Forkner.)

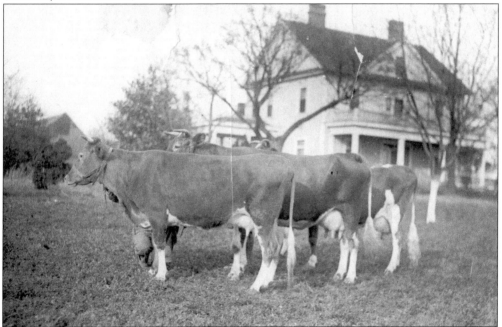

Three prize-winning cows are featured in front of the two-story Covington Road farmhouse, originally owned by Candler, whose primary residence was in Druid Hills. The center Guernsey, "Peerless Valentine," was among his favorites. He flatly refused two cash offers of $1,500 each for her. Judge Candler's cows frequently won ribbons at the Southeastern Fair. In 1912, the Forkner family began renting the farmhouse, and eventually purchased it in the 1920s. (Courtesy Tom Forkner.)

Bessie Allison Forkner and her husband, Ben Sands Forkner, parented seven children, five boys and two girls. Mrs. Forkner often entertained socially, and frequently hosted the 35-member Junior League of the Methodist Church of Ingleside. At her parties, dinner was served and games were played. As superintendent of the Sunday school, Mr. Forkner treated guests to his inspirational speeches. (Courtesy Tom Forkner.)

The land behind the elementary school was a popular play area for children. Here, the Forkner clan gathers with their dogs atop a bale of hay. Seen here, from left to right, are: (front row) Lawrence and Ben; (standing) Kathryn, Louise, John (atop bale looking back at dog), and Tom. The youngest Forkner boy, Bill, had not yet been born. (Courtesy Tom Forkner.)

Ben S. Forkner, Jr., born in the farmhouse in 1914, seen with pal and younger brother, Tom, born 1918, in front of the well at the farm house in 1923. A large, full-bearing pecan tree, and immense magnolia, provided both healthful climbing and a peaceful setting on the large lawn, which was sown in alfalfa. "We didn't even have a lock on the door until 1941," recalls Tom. (Courtesy Tom Forkner.)

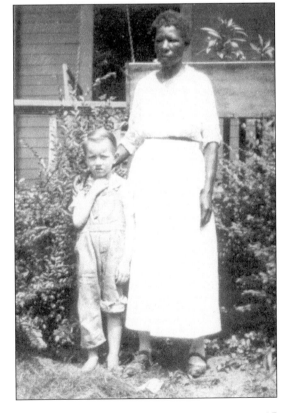

Pictured here are young Tom Forkner, age six, and Annie Mae, who was employed by Ben and Bessie Forkner. Annie Mae remained with the Forkner family until she passed away, several years after all seven children had grown up and moved away. (Courtesy Tom Forkner.)

17

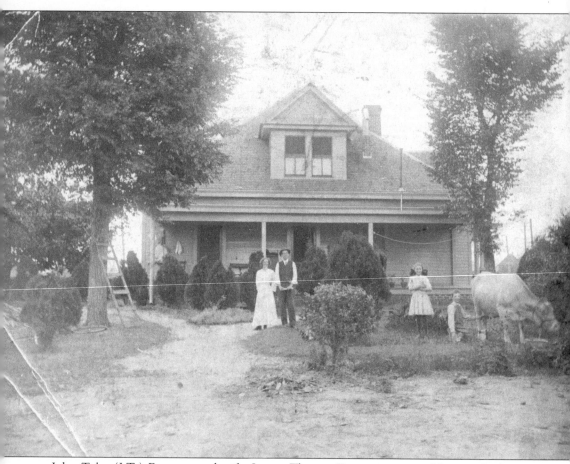

John Tyler (J.T.) Freeman and wife, Leona Thomas Freeman, pictured here with their two children, Rachel (standing) and True (milking the cow), built "The Homeplace" in 1913 with an address of 37 Avondale Road. The Freeman's owned acreage extending from Avondale Road beyond Dartmouth. From 1903 until The Homeplace was finished, they lived in a small barn on site. J.T. and Leona opened much of their land to sharecroppers, who raised cotton. Sharecropping was banned, however, after Willis purchased the property for Avondale Estates. In 1924, J.T. and Leona sold a large portion of their land to Mr. Willis, but kept The Homeplace and an entire block of Clarendon. The Freeman land, along with a portion of Redmond Hill's farmland, became part of Avondale Estates, making the city "one mile wide and one mile long." The Homeplace was literally days away from being named a National Historic site when it was demolished in the 1980s, under opposition, to make way for the development of new homes. (Courtesy Lee and Milton Shelnutt.)

Pictured here is lovely Rachel Freeman at age 16, *c.* 1917. Rachel married Lemuel Dow Shelnutt in June 1920. In 1921, she gave birth to twins, Milton and Mason, in The Homeplace. In 1924, J.T. built the cream-colored brick house at 3 Clarendon for Rachel and her family. Rachel was Avondale Elementary School's Lunchroom Director for over 20 years. Milton still lives in Avondale Estates with wife, Lee. (Courtesy Lee and Milton Shelnutt.)

In 1923, J.T. Freeman built 33 Avondale Road for his son, True, pictured here at age 17. On December 27, 1921, True Freeman married Mary Hines of Moreland, Georgia. A highly educated woman, she played an integral role in Avondale's educational system, serving over 40 years as a teacher and principal. True became a leader in business, church, and the community. Mary and True had one son, Roy. (Courtesy Lee and Milton Shelnutt.)

19

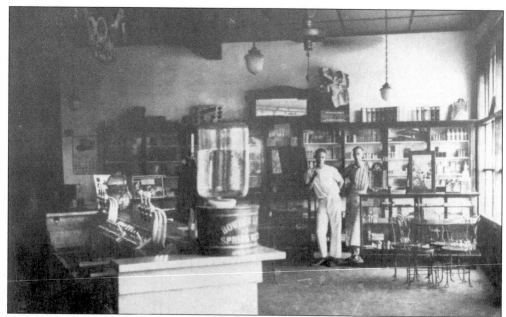

True Freeman owned the Village Drug Store where nephew, Milton Shelnutt, 12 years old, hopped curbs for ten cents hour. Both the Drug Store and Avondale Pharmacy offered curb service for sodas and sundaes back then, and engaged in friendly competition for customers. True later opened Freeman Hardware. Pictured here is True (left) with longtime employee, Billy Byrd. Freeman Hardware remained an Avondale landmark well into the 1960s. (Courtesy Freeman Collection.)

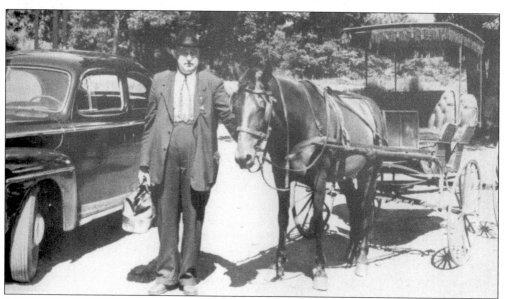

Dr. Conrad Lacunious Allgood, a World War One veteran, and his wife, Lucy Goodman Faulkner, parented eight children, six girls and two boys. He lived in the neighboring town of Scottdale, although he owned property in Avondale. Dr. Allgood never pressed patients for his fee, but would trade for fruit or chickens and the like. In Stone Mountain, to this day, there stands a school, a church, and a road named in honor of Dr. Allgood. (Courtesy Lucy Flowers.)

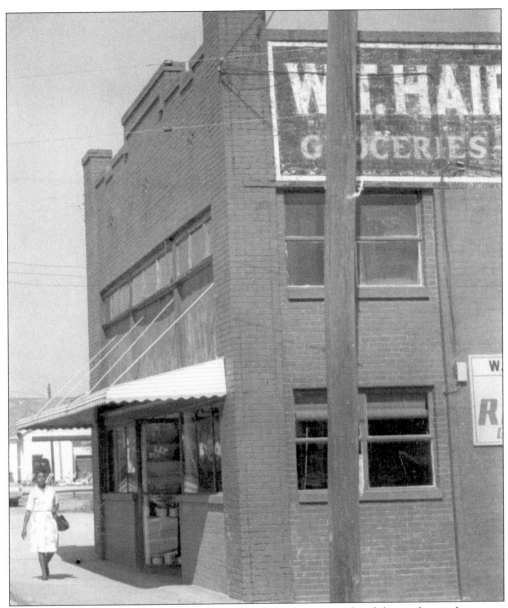

W.T. Hairston's, with its concrete floors and bridles hanging overhead, has a place in history as the old-fashioned general store. For half a century, people shopped at W.T. Hairston's for fresh produce, penny stick candy, slop jars, octagon soap, kerosene oil, wash boards, lump coal, hand-push plows, and you-name-it. The Hairston family moved to DeKalb in 1818. William T. Hairston first rented the store from George Willis on February 1, 1931. His son, Burgess T., then a young man of 22, was a partner. A third generation ran the store when B.T.'s son, Jerry T., worked as general manager well into the 1970s. The "T" stands for Towers, a name well recognized historically throughout the county. Mrs. Hairston's family was also among the early settlers. Her father, D.E. Austin, worked on the roads, pool, and lake in Avondale Estates. W.L. Henley occupied the historic building prior to the Hairston's. Prepared for any emergency, he kept a supply of coffins upstairs. According to the Hairston's, this was the only business Mr. Willis did not tear down or remodel. (Courtesy Avondale Estates Garden Club.)

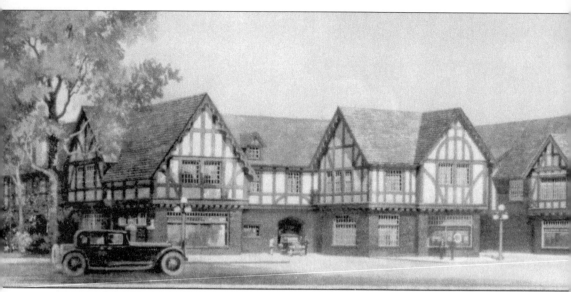

Artist and Civil War Historian Wilbur G. Kurtz (1882–1967) arrived in Atlanta in 1912. His knowledge took him to Hollywood, where he was a technical adviser during the filming of *Gone With The Wind*. He created murals for many Atlanta buildings, including the Battle of Atlanta in Grant Park's *Cyclorama*. Kurtz founded the Pen and Brush Club in 1913, whose patrons

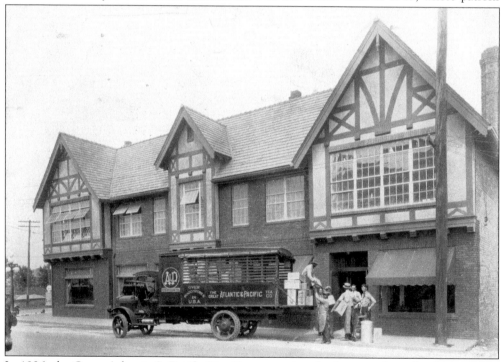

In 1926, the Great Atlantic & Pacific Tea Company signed a five-year lease for their store in the Avondale Estates business block. This store was one of the most completely equipped of the company's large chain in Atlanta. At the time, the Avondale Estates business center was in a strategic position. Records note 30,000 persons to the east and west looked to Avondale as their trading center. (Courtesy Tom Forkner.)

22

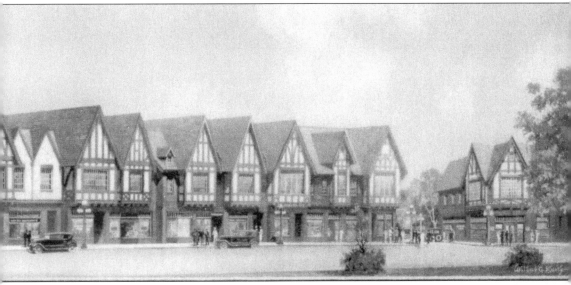

included Judge John S. Candler. George and Lottie Willis shared an interest in the arts, and Wilbur Kurtz was well known to them. In the 1920s, Willis commissioned the artist to create several paintings of Avondale Estates, where today they can be viewed in the City Hall and the Community Club. (Courtesy Gerrill Kohn Shealy.)

Only a handful of longtime residents recall the old icehouse. As a small boy, Milton Shelnutt used to pull his wagon from The Homeplace to the icehouse for Grandma Freeman, buy a 25-pound block of ice for a nickel, and bring it back to the icebox. Refrigerators back then were scarce. The old icehouse, on the present site of Avondale Pharmacy, was torn down in the early years to make way for new business. (Courtesy Tom Forkner.)

Marion C. "Mac" Farrar is pictured holding his son, Bob, c. 1918. Robert H. Farrar became a Georgia state senator. Mac lived in Avondale for over 65 years, receiving his appointment as postmaster in 1934. Back then, the post office was located in the village. His predecessor, Annie Ford, used to haul her sack of outgoing mail to the depot (present site of Georgia Duck and Cordage) and hang it on a pole to be hooked by the passing train. (Courtesy Lee and Milton Shelnutt.)

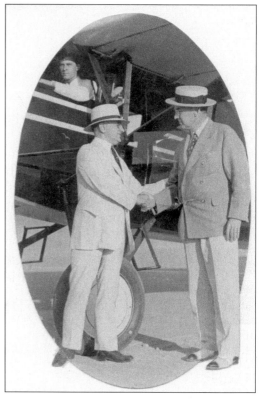

E.M. Moffett, Secretary for the Avondale Estates project, and George F. Willis (right), Founder, are pictured together during the mid-1920s. Mr. Willis was a dapper figure in his derby hat, spats, and cane thrown over his arm. He often visited residents and was frequently seen driving around town in his Pierce Arrow automobile with a pair of vases on the front, always filled with fresh flowers. (Courtesy Marion Reinhardt.)

During the 1920s, Georgia Power installed lines along Covington. The original Old English, globed street lamps were set in Avondale, and landscaping with evergreens had begun. The globed street lamps were the first in the city; they were replaced in the 1930s by lantern-style lamps. Successive replacement of street lamps would follow Avondale's history. In this east-facing plaza photograph, the crest of Stone Mountain can be seen rising just behind the farmhouse. (Courtesy Tom Forkner.)

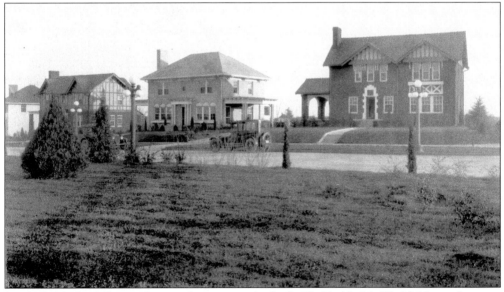

In 1925–26, the following historic homes were built: 9, 10, 11, 13, 14, 15, 16 (shown here are 14, 15, 16) Avondale Plaza; 5, 11 Avondale Road; 1, 3, 9, 14, 21 Berkeley; 3, 6, 26, 32, 56, 79, 82 Clarendon; 10 Covington; 12, 13, 17, 22, 36, 40, 71, 94 Dartmouth; 4, 5, 14, 15, 18, 19, 20, 25 Exeter; 1, 5, 14, 16, 23, 27 Fairfield; 11 Fairfield Plaza; 6, 10, 11, 15, 18, 22, 25 Kensington; 13 Kingstone; 12, 36 Lakeshore; and 14 Wiltshire. (Courtesy Tom Forkner.)

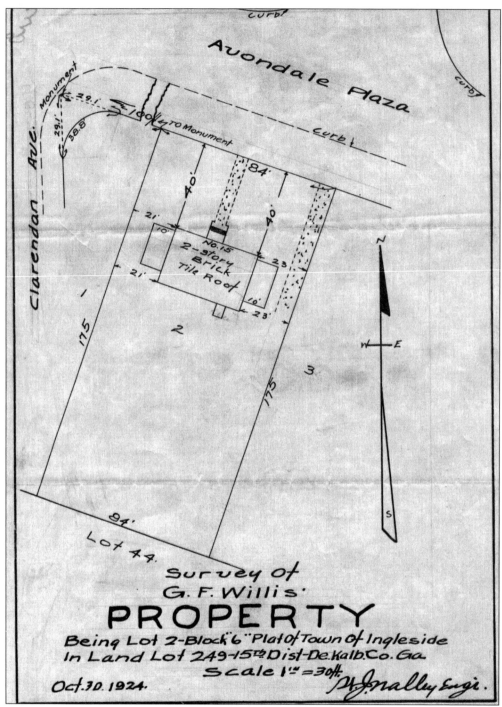

Taking center stage was 15 Avondale Plaza. This original survey, dated October 30, 1924, shows the depth of the property and describes in brief detail, the type of home to be constructed, a two-story brick with tile roof. The majestic Italian Villa (opposite) was the first home to be built and sold on Avondale Plaza. The original seven historic houses on the plaza are numbers 9, 10, 11, 13, 14, 15, and 16. (Courtesy Marion Reinhardt.)

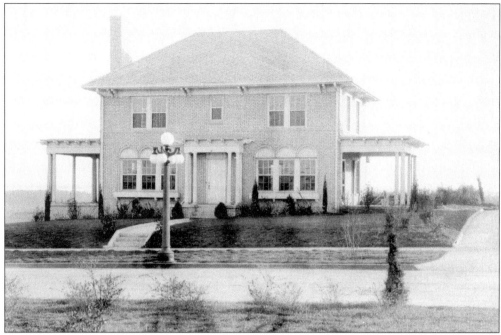

Mark J. Reinhardt, a New York-based salesman with F&W Grand Company, purchased 15 Avondale Plaza in March of 1925. He relocated wife, Charlotte, and young daughter, Marion, from New York to Avondale Estates, where they lived for over 50 years. Mr. Reinhardt could often be seen on the prestigious Ingleside Golf Course with highly-touted Scottish Pro James Livingstone, for whom a street near Avondale is named. (Courtesy Tom Forkner.)

Pictured here on her front porch, Marion enjoyed being on stage even as a young girl. She began ballet and tap dancing lessons at age three. By age six, she discovered a natural talent for playing the banjo, a rare choice of instrument for a young girl. During Mr. Willis' visits, the vibrant little red-head garnered an enthusiastic fan with her impromptu acts. (Courtesy Marion Reinhardt.)

Marion Reinhardt, age eight, in the downtown Atlanta studio of her instructors, Austria's Madam Lola Menzeli, and her Russian-born husband, Senia Solomonoff. Marion's desire to dance and play the banjo would become her lifelong pursuit both as a professional performer and teacher, entertaining thousands throughout her 50-year career and paving the way for hundreds of young children who took lessons in her studio. (Courtesy Marion Reinhardt.)

At her seventh birthday party, Marion joined in play with the rest of the girls. Many of the children pictured above lived in or near Avondale Estates, such as Hortense Pounds, daughter of Dr. J.E. Pounds, the city's only other doctor at the time, besides Dr. Allgood. "Tensie" Pounds and Marion Reinhardt have maintained a friendship lasting over 70 years. (Courtesy Marion Reinhardt.)

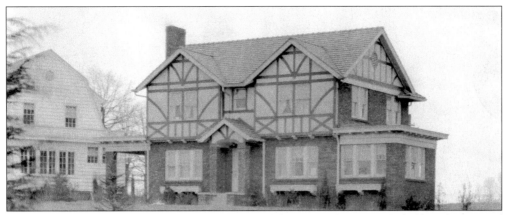

The key feature of 10 Avondale Plaza is its English Tudor design, with half-timbering and steeply pitched gables, the signature style of the city. The key interest in the house, however, is that Mr. Willis generously offered the home to Gutzon Borglum during his initial carving of the Stone Mountain Confederate Memorial from 1923–1925. A state historic marker in front of the home notes the Borglum era. (Courtesy Tom Forkner.)

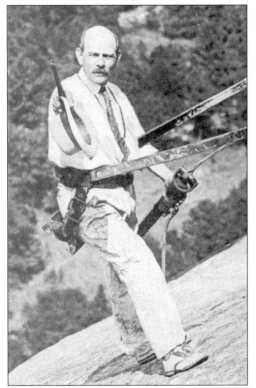

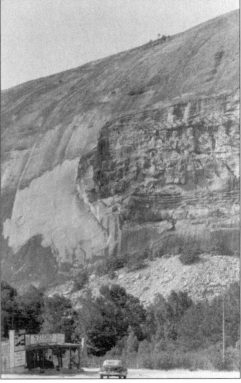

Left: This postcard depicts a close-up view of the famous sculptor descending to the precipice of Stone Mountain on June 18, 1923 to begin initial carving of General Lee's figure, slated to be larger than a 16-story building. (Courtesy Allan Kirwan.) *Right:* This 1920s postcard shows the sculptor's Studio at the base of Stone Mountain, towering 825 feet from the ground. By now, Borglum had achieved the attention of the world. Dozens of his works were among the rich treasures on display in galleries, public buildings, and parks, in cities such as Washington, D.C. and New York. (Courtesy Allan Kirwan.)

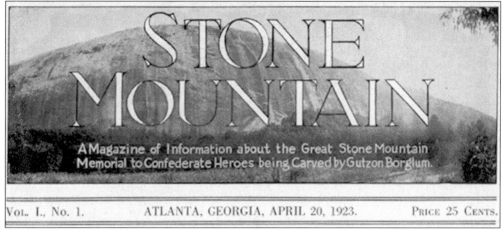

STONE MOUNTAIN

A Magazine of Information about the Great Stone Mountain
Memorial to Confederate Heroes being Carved by Gutzon Borglum.

Vol. I., No. 1. ATLANTA, GEORGIA, APRIL 20, 1923. Price 25 Cents.

In 1915, Borglum accepted the Stone Mountain commission from the United Daughters of the Confederacy (UDC), and, in 1916, Samuel H. Venable deeded the north face of the mountain. The photograph shows a cover excerpt from the first issue of *Stone Mountain* magazine, a fundraising vehicle. In the midst of a 1925 funding dispute, Borglum destroyed his models, left Avondale Estates, and went on to carve Mount Rushmore. (Courtesy Mary Payne.)

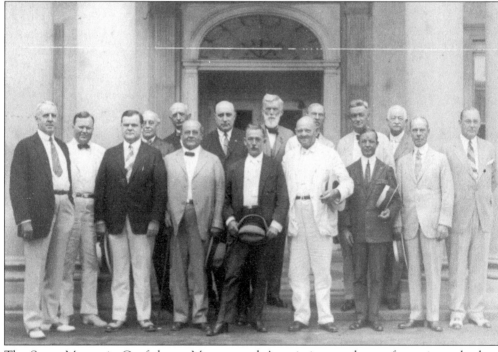

The Stone Mountain Confederate Monumental Association, made up of prominent leaders, was formed in 1915 to oversee the country's largest carving. In 1928, George F. Willis (first row, right), yielded to the pressure, headed by Governor Hardman, to accept presidency. Willis delivered a speech to the UDC, and prepared a written statement urging support of Augustus Lukeman, successor to Borglum, to facilitate the carving of Jefferson Davis, Robert E. Lee, and Andrew "Stonewall" Jackson. (Courtesy Special Collections Department, Robert W. Woodruff Library, Emory University.)

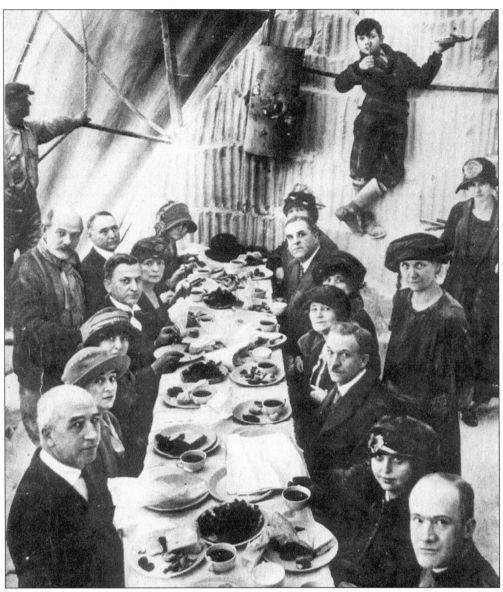

Prior to his departure, Borglum was honored at the unveiling of General Lee's head on January 19, 1924, (Lee's birthday anniversary) at which 20,000 people were present. The photograph above depicts the previous day, when a select party climbed the giant mountain and descended to a table set upon a granite shelf, which would eventually become General Lee's shoulder. Guests of Mr. Borglum were, seated from front to back, as follows: (right) Col. H.M. Smith (Chief of Staff of Gov. Trinkle); Mrs. Roger Winter, Atlanta; Gov. Brandon, Alabama; Mrs. Ella Sykes, Alabama; Mrs. Scotia Dunwody, Boston; Gov. Trinkle, Virginia; Mrs. Lee Ashcraft, Atlanta; Mrs. Borglum (behind Gov. Trinkle); Mrs. J.G. Tucker (behind Mrs. Borglum); and son, Lincoln Borglum (standing on a narrow foothold with a chicken drumstick in his hand); (left) Preston Arkwright, Atlanta; Mrs. Walter G.Roper, Atlanta; Mrs. Hollins N. Randolph (wife of the President of the Memorial Assn.); Gov. Neff, Texas; Mrs. Preston Arkwright; Mrs. Frank Mason (sister of Samuel Venable); Gutzon Borglum (behind Gov. Neff); Lee Ashcraft (behind Mrs. Arkwright); and Ted Carfman (worker). (Courtesy Mary Payne.)

The historic home at 13 Avondale Plaza, with its wide white clapboards and window boxes, illustrates the Colonial Revival style. The narrow cypress planted in front is a typical English feature. On May 10, 1926, owner Sidney G. Gilbreath, southern manager for bible publishers John C. Winston Company, wrote Mr. Willis a heartfelt letter of appreciation for the beauty he and his family discovered as residents of Avondale Estates. (Courtesy Tom Forkner.)

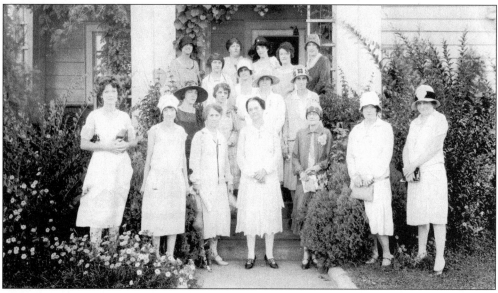

The Avondale Estates Chapter of the Service Star Legion celebrated Forget-Me-Not Day on September 22, 1926, at the home of Mrs. S.G. Gilbreath, President. Seen here, from left to right, are as follows: (first row) Mrs. J.B. Shiffer, Mrs. W.J. Cochrane, Mrs. I.T. Catron, Mrs. S.G. Gilbreath, Mrs. McClung, Mrs. P.B. Hicks, Mrs. W.C. Harris; (second row) Mrs. E. C. Talbot, Mrs. C.H. Black, Mrs. Milan, Mrs. Jolly; (third row) Mrs. D.J. MacKillop, Mrs. J.E. Pounds; (fourth row) Mrs. Charles L. McLain, Mrs. F.H. Heaton, Mrs. L.F. Meng, Mrs. J.E. Okell, and Mrs. Ray. (Courtesy Tom Forkner.)

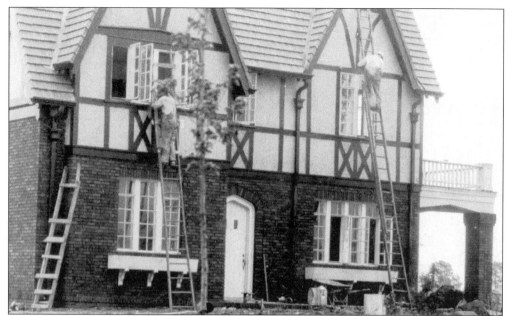

Workers put finishing touches on 10 Covington. Originally begun in 1923, fierce winds turned the skeletal wood frame into a pile of timbers, only to rise again in high style. The steeply pitched, pointed gables create an elegant English Tudor display, emphasized by the archway entrance, swing-out windows and window boxes. Willis contracted with the Ludowici Company in Chicago to create handmade tiles for this roof, and several others in Avondale. Original owners were the Harmon family. Mrs. Harmon was furniture buyer for well-loved Atlanta philanthropist, Dick Rich, of Rich's Department Store. In the photograph below, a car in the drive and door ajar suggests this may have been a model home. (Courtesy Tom Forkner.)

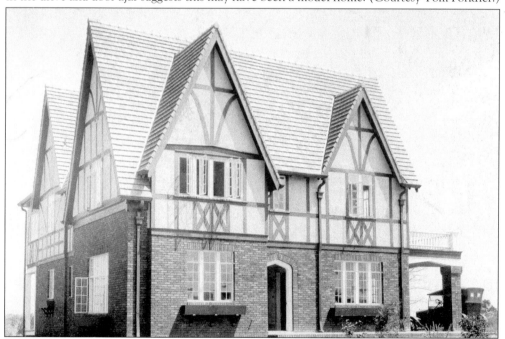

Built in 1925–26, 14 Kensington is one of few examples among the historic homes in Avondale, and Georgia, depicting the English Thatch Roof design. The Thatch Roof style gained popularity in the U.S. *c.* 1910. Note the eyebrow dormer, and the downward tuck of the shingled roof, creating a false thatched appearance. This unusual house was the home of popular studio photographer, Thurston Hatcher. (Above, courtesy Tom Forkner; below, courtesy Marion Reinhardt.)

FINE PHOTOGRAPHS
ATLANTA

May, 11th. 1926.

Mr. G. F. Willis,
Avondale Estates, Ga.

Dear Mr. Willis:-
It has been my
pleasure to live in Avondale since
last September and my family has
found it a most enjoyable place
in which to live.

Avondale certainly
offers more genuine things that go
to make up health and happiness than
any other place I know about and there
are more good things being added
every week. It certainly deserves
the great success that it has had
and as an Avondale citizen, I wish
for it and it's builder the best
of everything.

Very sincerely,

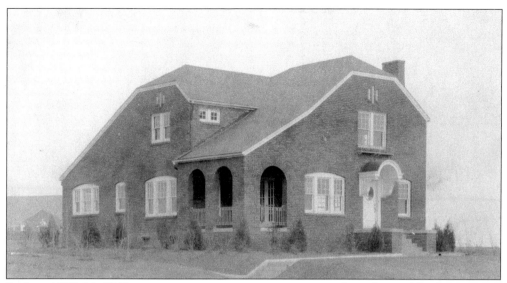

Built in 1925–26, 22 Kensington presents an interesting anomaly in design. The home's most defining feature is the long-sweeping English roof, with jerkin-head or "clipped" gable. The entrance displays a Colonial Revival style door, and the porch is of Spanish style. The J.L. Bond family, of DeKalb Supply Company at Sams Crossing, originally owned the home, which sits high on a grassy knoll. (Above, courtesy Tom Forkner; below, courtesy Marion Reinhardt.)

DeKalb Supply Company
DEALERS IN
LUMBER AND BUILDING MATERIAL
BRICK, LIME AND CEMENT

SYCAMORE STREET SAMS CROSSING

DECATUR, GA.

May 12th, 1926

Mr. G.F. Willis,

Avondale Estates, Ga.

Dear Mr. Willis:-

 I just wish to say what I think of Avondale Estates after living here one year. I was one of the first to move in and have watched with interest the rapid development of this splendid subdivision.

 I have been especially interested in the time and money you spend in beautifying the grounds for the homes and playgrounds.

 I think you deserve credit for developing a subdivision in which it is so delightful to live.

 Yours very truly

 J.L. Bond

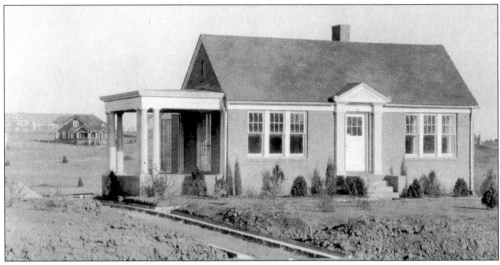

Ten Clarendon is a hallmark in historic cottages of the Classical Revival style. The pediment entry, flanked by classical pilasters, welcomed Avondale's first pharmacist, Dr. William Rogers. The windows, neatly grouped together in threes, offer an abundance of natural light. Classical columns are repeated in multiples of three on the sun porch. In the distance, through unpaved streets, the false thatched roof of 14 Kensington, and the elementary school can be seen. (Above, courtesy Tom Forkner; below, courtesy Marion Reinhardt.)

AVONDALE PHARMACY
Wm ROGERS, Proprietor
AVONDALE ESTATES, GA.

May 8th,1926

Mr. G. F. Willis,
Avondale Estates,Ga.

Dear Sir;-

It is most gratifying to me to take this opportunity of telling you that after residing in Avondale Estates for more that a year, I can truthfully say that in my opinion it is the South's most most wonderful place to live.

The residents of Avondale have not only all the con- veniences possible, but all the luxuries of the very rich. I have two children and Avondale has given them more pleasure, happiness and health than can be imagined. Every recreational advantage for both young and old has been looked after, and the high standard of living has been maintained in every respect.

In Avondale's vegetable garden and Dairy we are able to get the highest quality in food products at lowest cost.

In closing I wish to add that it is my belief that I could sell my home for at least a fifty percent profit on my investment. Anyone considering buying a home or making an investment should investigate Avondale, and if they do this I am sure they will share my views.

Very truly yours,

WR/B

Wm Rogers

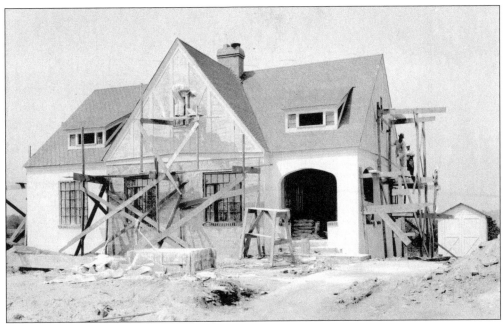

George Willis' plan called for construction of a minimum of 50 homes of the English Cottage style shown above. To accomplish the task, he worked with some of the finest developers in the city, including the Flagler Company, J.E. Smith, Charles H. Black, and H.A. Wagar & Company, among others. Developers sought opportunities to work with Mr. Willis, and were proud to be associated with the quality of homes being constructed in the highly publicized city of Avondale Estates. (Courtesy Tom Forkner.)

Builder and friend of George Willis, J.E. Smith constructed the medieval English Tudor style home at 13 Kingstone, complete with half-timbering and decorative trim work. The house is complemented by a large, sturdy garage, which is indicative of the mid-range between the smaller garage and the more elaborate to be found in the city. In the 1920s, it was popular to build a sun-parlor off to the side of the house. (Courtesy Tom Forkner.)

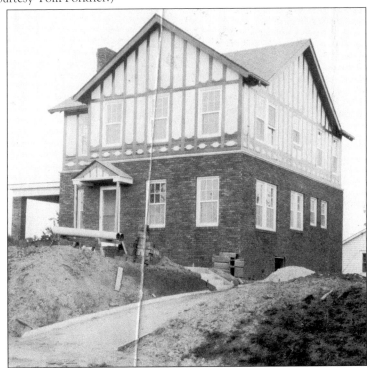

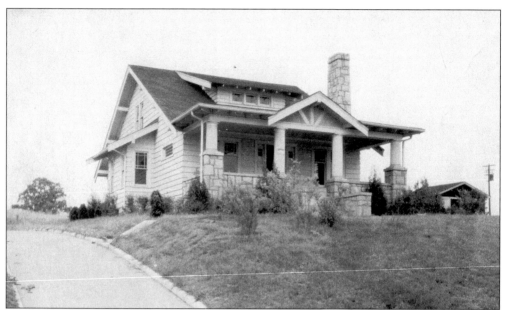

Ten Kensington showcases the Craftsman Bungalow style, a back-to-nature movement. The style has its roots in California, and became one of the most popular designs in the country from 1910–1930. This particular home is described as architecturally eclectic, in that it features an English half-timbering gable, combined with classical columns supporting a wide porch. With an original 1920s selling price of $11,250, the sign on its column reads, "Open." (Courtesy Tom Forkner.)

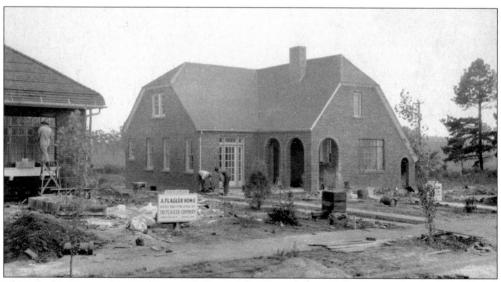

The Flagler Company built 5 and 7 Fairfield Plaza. Although Flagler built many homes in Avondale, he did not design the structures, but perhaps took them from architectural pattern books. Number 7 is of the English Cottage style, with jerkin-head or "clipped" roof, and Number 5 is designed to evoke a thatched roof appearance. The small arch to the right is also of medieval English origin, suggesting the marriage of garden to the house. (Courtesy Tom Forkner.)

Sixteen South Avondale proudly displays the English Tudor style of the city with its steeply pitched gables and half-timbering. It is set apart, however, by the decorative European touch of quoins around the front door, punctuated by stylish brackets overhead. Note the elaborate garage that repeats the architecture of the house. Drs. Allgood and Pounds welcomed the talented Dr. Isaac Catron in the 1920s, after he purchased this elegant home for his family. (Courtesy Tom Forkner.)

Georgia architect Leila Ross Wilburn (1885–1967) designed 23 Dartmouth, along with several others in Avondale Estates, and included them in her pattern books. Wilburn is the only woman architect in the country whose plan books can be documented. In them, she offered five specific patterns, available by mail. Wilburn lived on Adams Street in nearby Decatur. Her historic home pattern books are housed in the Atlanta History Center. (Courtesy Tom Forkner.)

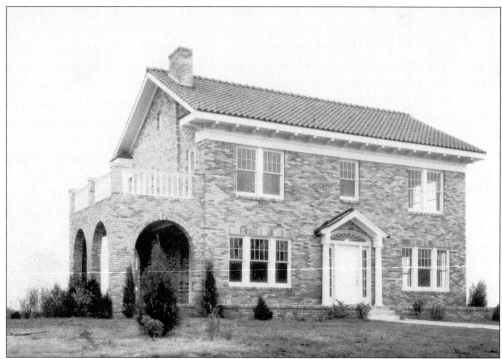

Twenty-seven South Avondale Road is a grand eclectic mix of the Historic Revival style. It features a Colonial doorway, with Federal fanlight, large brackets at the cornice, and a tile roof. The first mayor of Avondale Estates, Claude Pyburn, purchased the home, which had an original 1920s selling price of $15,000. Mr. Pyburn moved to Atlanta in 1905. He served as mayor and judge of Avondale Estates from 1929 to 1939. (Courtesy Tom Forkner.)

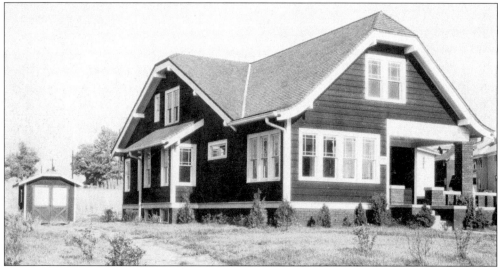

One Berkeley is a pure example of the back-to-nature Craftsman Bungalow. Houses of this design were often painted brown or dark green, and trimmed in white. The wide eaves show visible structural support, and windows are paired together to flood the house with light, also typical of the Craftsman Bungalow. One Berkeley had a 1920s selling price of $11,850 and was originally owned by the Lilly family. (Courtesy Tom Forkner.)

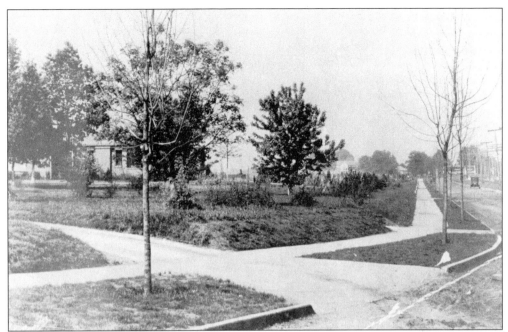

This 1926 scene shows the sidewalk, the driveway to the Homeplace, and Avondale Road, graded, but not yet paved. Early on, streets were laid using mules and dragpans. Later however, Willis agreed to experimentally test new Ford tractors, rather than mules, to lay streets. He also used one of the first backhoes, a tremendous steam machine with wheels that moved on heavy wooden mats, which kept them from sinking in the muddy, Georgia red clay. (Courtesy Lee and Milton Shelnutt.)

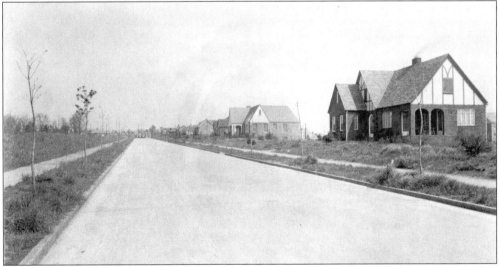

This north view of Clarendon from Kingstone shows the sparse development of homes, but streets are paved, and early landscaping is underway. Mr. Willis kept a watchful eye on the landscaping of Avondale Estates. Richard B. Cridland, landscape architect, and J.G. Hardeman, gardener, (both appointed by Willis in 1925) worked side by side with Willis to create the naturalistic plantings of streetscapes, parks, and plazas. (Courtesy Avondale Estates Garden Club.)

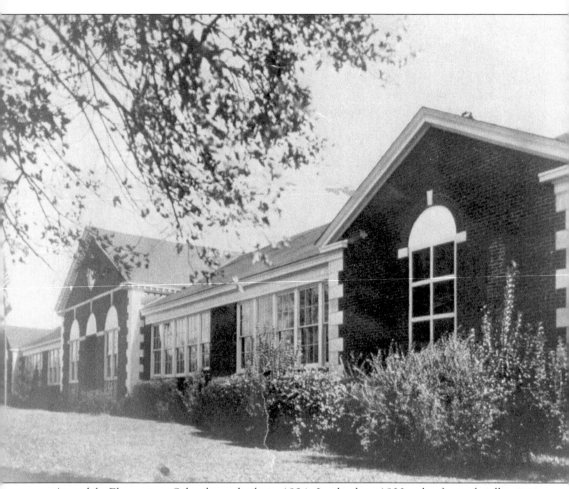

Avondale Elementary School was built in 1924. In the late 1800s, the first schoolhouse on record was Professor Meacham's one-room wooden building on Cedar Street, where Mrs. Camp taught all grades during the week; on Sunday's Professor Meacham preached there. Around the turn of the century, a two-story wooden building was built at the corner of Old Stone Mountain (now Clarendon) and Rockbridge. In 1912, a brick building replaced the wooden one, and remained the only school until 1923 when Mary Freeman bolstered campaign efforts for two new schools. That summer, J.T. Freeman, Ben Forkner, and John Scott were elected trustees of the district. In December, bonds amounting to $75,000 were voted on and sold. Mr. Willis donated property for Avondale Elementary, and Mr. Scott donated land for Scottdale School. By 1924, both schools had been constructed, each with six classrooms, restrooms, a principal's office, and an auditorium with no seats. J.T. Freeman donated seats for Avondale Elementary, and the community provided benches for Scottdale. Dr. Wallace Alston, who became President Emeritus of Agnes Scott College, served as principal of Avondale Elementary during the mid-to-late 1920s. (Courtesy Lee and Milton Shelnutt.)

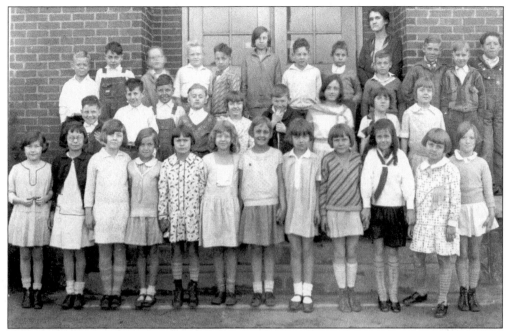

Miss Annie Ruth Burgess' third grade class at Avondale Elementary School, c. 1930, is shown above. Miss Burgess was aunt to the prominent Theron Burgess, Clerk of DeKalb County Courts at the time. Milton Shelnutt, one of the twins born to Rachel Freeman Shelnutt, is pictured in the third row, seventh from left. (Courtesy Lee and Milton Shelnutt.)

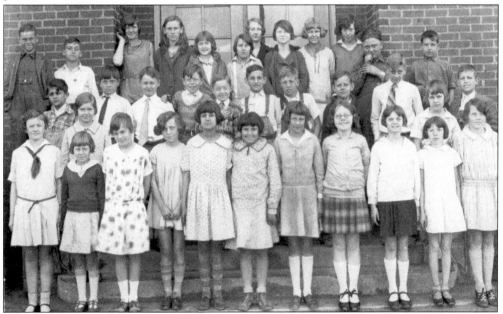

Miss Martha Pratt's fifth grade class at Avondale Elementary School, c. 1929, is shown above. Miss Pratt lived with her mother and father on Kensington Road. All of the teachers, except one, were unmarried. Strict school policies were enforced, including no dates with young men, until the weekend. Marion Reinhardt is pictured in the first row, fourth from right. (Courtesy Marion Reinhardt.)

George F. Willis emphasized in all publicity that Avondale Estates possessed "every known help to healthful play" for children. To this end, his vision materialized with over 30 acres of parks, playgrounds, and athletic fields throughout the community. Children were afforded the finest playground equipment, swings, slides, and carousels. The pool, tennis courts, baseball diamonds, basketball courts, football gridirons, and lake offered many opportunities for play; nearby Avondale Riding School provided equestrian lessons. Children were not allowed, however, on the golf courses. (Above, courtesy Tom Forkner; below, courtesy Marion Reinhardt.)

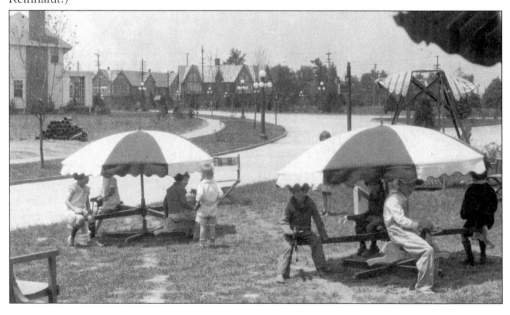

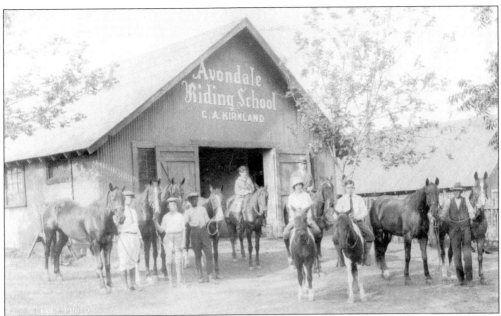

C.A. Kirkland, owner of Avondale Stables, was a champion rider and instructor. The stable, located at the present site of Twin Oaks, was stocked with selected thoroughbred five-gaited saddle horses and gentle ponies for the young riders. The natural beauty of Avondale Estates took on deeper meaning to the lover of equestrian sports. There were miles of meandering bridle paths and trails, dropping deep into fragrant forest dells, and rambling streams. In the fall, Mr. Kirkland arranged a series of cross-country rides, hunts, paper chases, and moonlit gallops in the crisp night air. In the photograph below, Mr. Grales, foreman, kept horses for Mr. Willis, available for residents who did not own them but were eager to ride. (Above, courtesy Marion Reinhardt; below, courtesy Tom Forkner.))

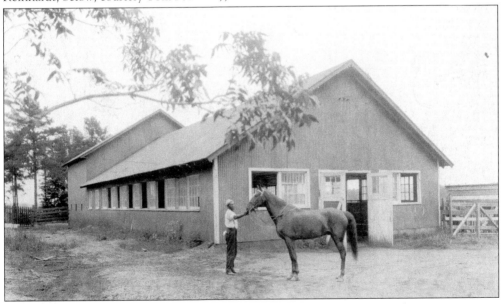

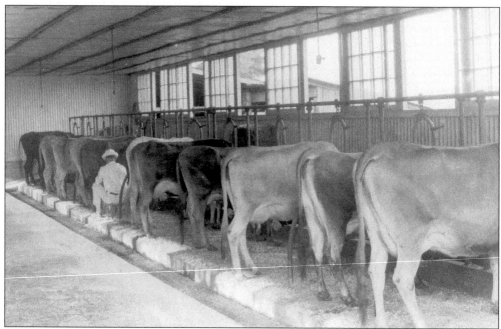

Avondale Dairies was located on what was originally Judge John S. Candler's dairy farm. The dairy barns and milk houses were built by Judge Candler to accommodate his prize herd. Fully equipped with modern stanchions, it was one of the most complete dairies in the South. The main barn accommodated 30 cows, all full-blooded Jerseys, with the exception of two Holsteins, for customers who preferred less-rich milk. Dairy products were delivered to Avondale homes every morning. Manager, J.T. Cain, in his May 6, 1926 letter to Mr. Willis, stated, "I do not believe that any finer milk or cream has ever been sold in Atlanta." (Above, courtesy Tom Forkner; below, courtesy Marion Reinhardt.)

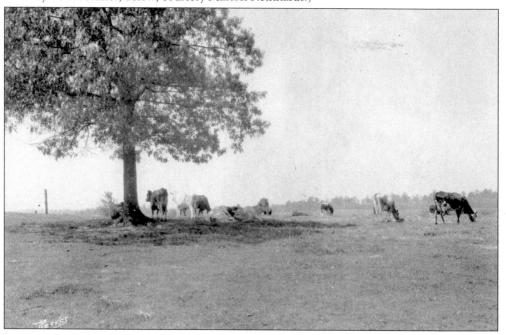

Avondale Nursery, at Midway Road, presented residents with thousands of seedling trees, flowering shrubs and vines, 12 varieties of roses, and over 200,000 evergreens. In 1926, Robert B. Cridland, landscape architect, wrote Willis after observing Avondale's first year growth, noting "the proper use of plant material, is being carried out successfully. I feel that those who have their homes within its boundaries may say, as the Prophet of old, that their lines are truly drawn in pleasant places." A nearby six-acre tract of land, supervised by W.B. Deckner, was cultivated for growing vegetables. In his 1926 letter to Willis, Deckner reported that the vegetable garden was planted "to provide fresh vegetables at cost," and "to prove that no better soil or climate for growing any kind of vegetable can be found anywhere else in the whole country." (Courtesy Tom Forkner.)

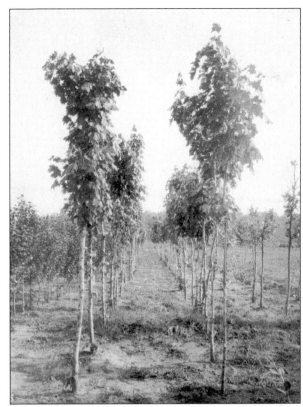

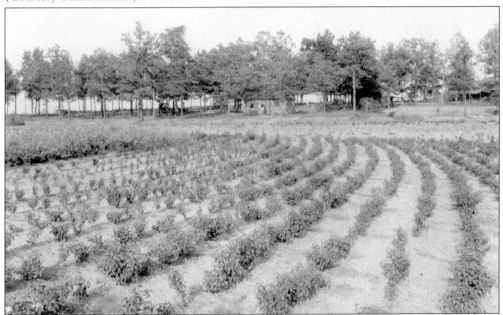

Mr. Willis described the pool as being "set like a precious gem in a grove of patriarchal oaks." When Avondale Estates was still known as Ingleside, the watering hole was called "Ice Cream Springs" because of the cool water springs located under Dartmouth, at or near the present entrance to the pool. Mr. Willis, enamored with the area, chose it as the site. By 1925, construction was underway for the pool, 107 feet long, 49 feet wide, and varying in depth from 2 1/2 feet to 11 feet. The spring supplied water for the pool, except when it was cleaned. Then, it would be filled halfway with water from the county, and the remainder with spring water. The pool was filled and drained several times before painters struck upon a color that would tint the water to Mr. Willis' satisfaction. (Courtesy Tom Forkner.)

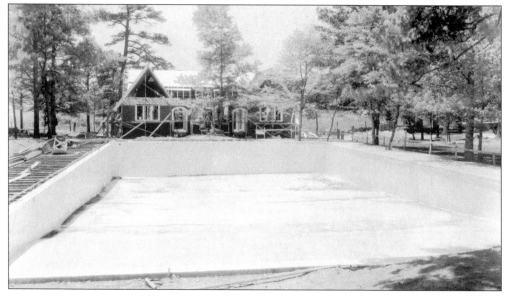

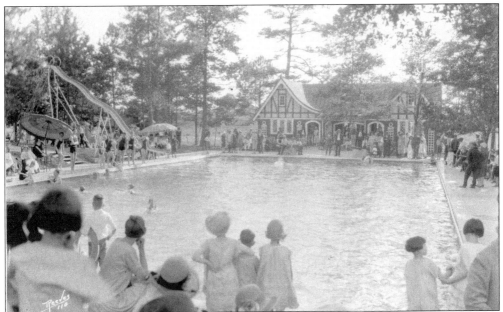

Opening day at the pool, c. 1927, is pictured above. In those early years, residents could swim for free before noon. Miss Perry and lifeguards offered private lessons for all ages. The wooden planked deck was eventually replaced due to splinters and warping over the years. Lifeguards worked 12 hours a day, earning $7.00 per week. Swim meets were often held at the pool, followed by picnic lunches, softball games, and three-legged races. There were even fashion shows with Avondale beauties presenting the latest styles in swimwear. Occasionally, evening movies would be shown in the pool house. The Fourth of July marked a traditional gathering on the pool grounds, or the banks of the lake, to watch fireworks. Today, the pool is a private membership, operating under the authority of elected board members. (Courtesy Marion Reinhardt.)

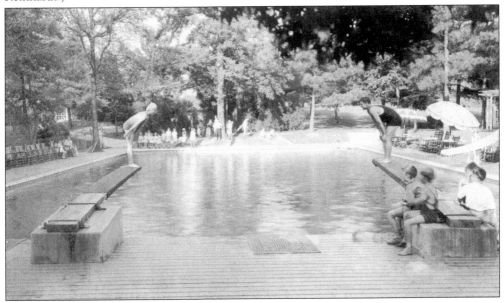

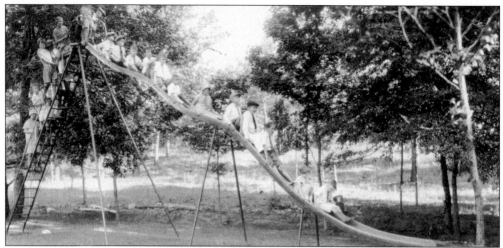

On Sunday morning, October 11, 1925, the *Atlanta Journal* featured an article proclaiming the joys to be found for children of all ages in Avondale. The headline, which accompanied the photographs above and below, read: "Children Frolic Here Amid Nature's Beauties." The article reported, "Not the least of the exceptional advantages that are causing thoughtful parents with growing children to turn with every-increasing frequency to Avondale Estates as the ideal home community are the splendid recreational facilities designed to meet the fun-loving needs of every child, big or little." The giant slide and gently undulating merry-go-round were among the most popular amusements under the shade trees of Willis Park. (Courtesy Marion Reinhardt.)

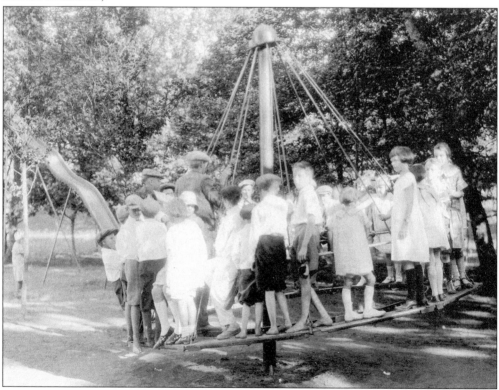

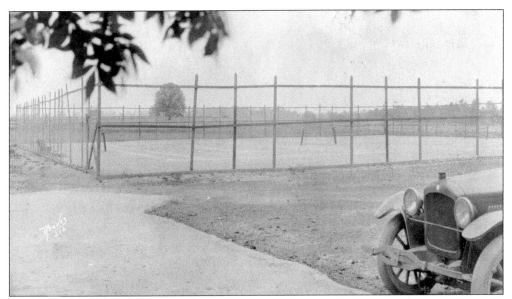

Early publicity always included the abundance of wholesome outdoor life offered in Avondale Estates, complete with top-notch tennis courts located next to the pool in Willis Park. Within walking distance was the Forrest Hills Golf Course, providing tee-off seven days a week. The challenging nine-hole course, with its expansive fairways, was kept in pristine condition. The photograph below depicts the Golf Clubhouse, which was destroyed by fire and never replaced. (Above, courtesy Marion Reinhardt; below, courtesy Tom Forkner.)

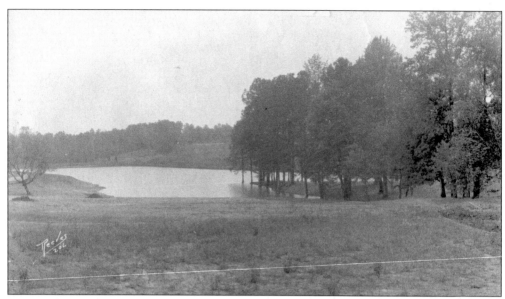

On October 11, 1925, the *Atlanta Journal* announced "the mountain will come to Mahomet" with the construction of Lake Avondale (shown facing south), 850 feet long, 350 feet wide, with a depth of 25 feet. Work on the lake was well underway through a contract awarded to D.E. Austin. A 25-foot concrete dam backed up several streams into a natural basin, formed by sloping hills on all sides. (Courtesy Avondale Estates Garden Club.)

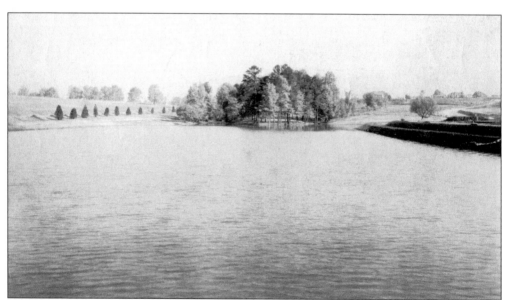

Lake Avondale (shown facing north), situated in the very heart of the city, was actually the first of several lakes that Willis had planned. The broad surface of Lake Avondale was perfect for canoeing, regattas, and other colorful events. Originally, Willis featured sandy beaches, boat and bathhouses, and a large clubhouse. Although swimming in the lake was popular, beaches failed to materialize as the sand kept sinking. (Courtesy Avondale Estates Garden Club.)

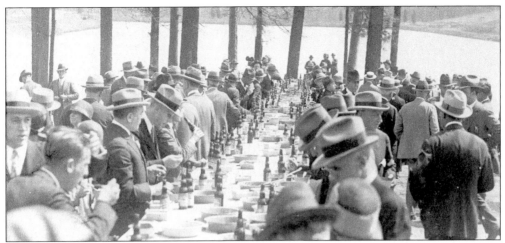

On October 11, 1925, the *Atlanta Journal* reprinted a letter from Albert S. Adams, president of the Atlanta Real Estate Board, praising George Willis: "He has taken a piece of raw land and changed it into one of the most beautiful residential parks that can be found in America. He has shown his faith in Atlanta and his confidence in its continued growth by investing hundreds of thousands of dollars in a venture that would have staggered any man with less vision of the possibilities of Atlanta and faith in its future." In 1926, Mr. Willis celebrated Avondale Estates with a lakeside barbecue, gratefully acknowledging his associates, the Atlanta Board of Realtors and developers who worked so diligently to make his ideal city a reality. Willis is shown below (right) in a candid moment with developer J.E. Smith. (Courtesy Tom Forkner.)

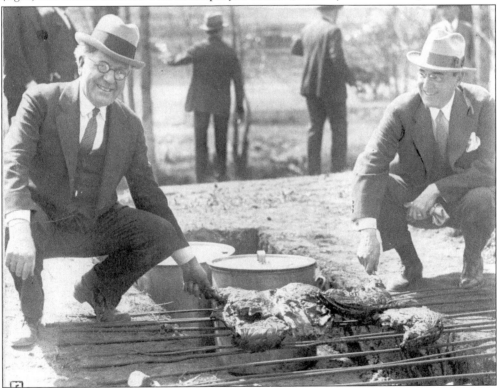

Prominent Atlanta archithect, Arthur Neal Robinson, designed the Avondale Community Club, as well as the Pool House and English Tudor Village. Originally built as a boat and bathhouse, the Community Club would later become the center of the city's social and civic activities, from garden club meetings to weddings and holiday gatherings. At the time the "Bath and Boat House" was built, the original Community Club was located upstairs in the old English village. (Courtesy Avondale Estates Garden Club.)

In the letter to True Freeman, shown at right, a list of amenities featured in the upstairs village club offered a ladies gym, men's gym, bowling alleys, billiards, private party rooms, dance floor, and social hall. Rooms were carpeted and luxuriously appointed. The club was a retreat for Avondale's elite, and a prestigious meeting place for visitors. The club later moved to the Avondale Community Club on Lakeshore Drive. (Courtesy Marion Reinhardt.)

Avondale Community Club

MEMBERSHIP RESTRICTED TO PROPERTY OWNERS OF AVONDALE

FEATURES:
LADIES' GYM
MEN'S GYM
BOWLING ALLEYS
BILLIARDS
PRIVATE PARTY ROOMS
DANCE FLOOR
SOCIAL HALL
IN FACT EVERYTHING TO
PROMOTE THE BEST
COMMUNITY SPIRIT AND
SOCIAL ACTIVITIES
OF AVONDALE

Avondale Estates, Ga.

December 1st, 1926.

Mr. True Freeman,
Avondale Estates, Ga.

Dear Mr. Freeman:-

The Avondale Community Club takes pleasure in advising that you have been unanimously elected a member of the club--with the distinction of "Charter Member".

December 15th has been fixed as the date for closing the list of charter members and therefore request is made that you immediately advise us of your intention to become a charter member by sending the Secretary your check for the initiation fee, and if you wish to do so at the same time, you may include monthly dues for whatever period of time you wish.

Application has already been made for a corporation charter in order that your Club officers may be clothed with the proper legal authority to protect the Club's interest.

Your Committees and Board of Governors have been working with might and will to devise simple and sensible plans for the successful operation of the Club and a glance at the enclosed copies of constitution, by-laws, rules, etc., is convincing evidence of the truth of this statement.

A few members have already paid their initiation fees, but many have not, simply because they had not been apprised of the fact that we were ready to function. No monthly dues whatever have been paid as yet.

Let's start this club with a "bang". The more service and thought and work each individual puts into it, the more good he will get out of it.

Very truly,

AVONDALE COMMUNITY CLUB

W. O. Paysler
Secretary-Treasurer.

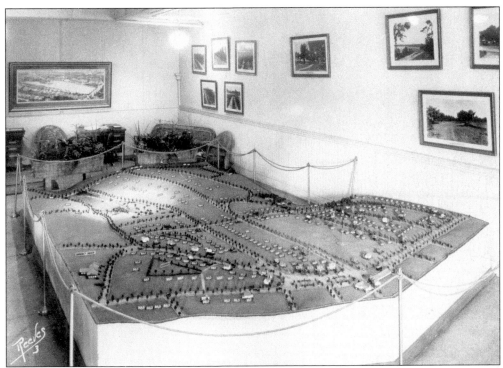

In the 1920s, Atlanta's interest in Avondale Estates piqued. To accommodate the mounting curiosity, a downtown Atlanta hotel set up one of their meeting rooms, displaying a miniature layout of Avondale Estates. It is interesting to note that Willis only built on every other lot, possibly a marketing strategy to promote sales. Photographs of the town once known as Ingleside, and also the famed Wilbur G. Kurtz rendering of Lake Avondale, hung on the walls in the meeting room, as pictured above. Buses outside the hotel provided transportation for people wanting to visit Avondale Estates and view the property firsthand. In the photograph shown below, others chose to take the picturesque drive in their own vehicles. Parked in the red clay soil, visitors scouted lots and toured model homes. The model homes were considered interesting enough for young couples to tour on a date. (Courtesy Tom Forkner.)

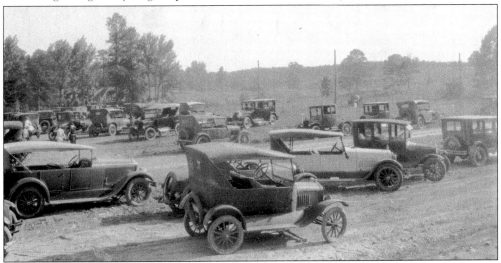

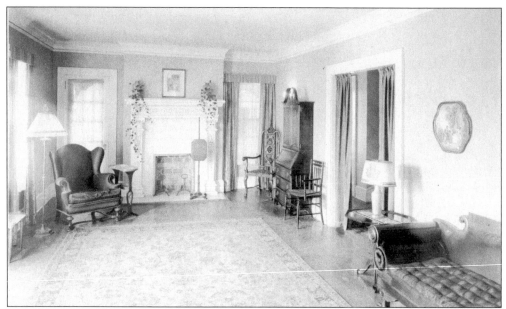

Interior refinement and good taste complemented the external loveliness of Avondale Estates, as shown here in the home of Dr. and Mrs. Isaac Catron. The ornamental focus of the Victorian living room is the grand Renaissance period fireplace, one of only six imported from Europe and placed into selected homes by Willis. In the 1920s, this type of fireplace was more decorative than functional, and was considered a symbol of happy family life. (Courtesy Tom Forkner.)

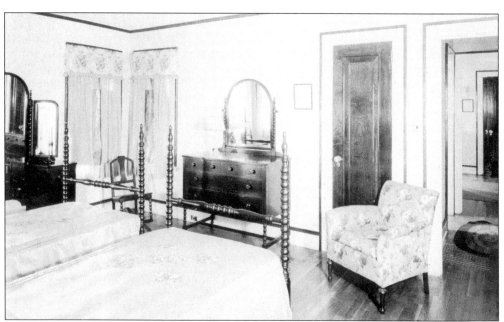

The model Victorian bedroom suite shown above speaks in minute detail with its spindle bedposts, matching dresser, vanity mirror spindles and legs, repeated in the small rocking chair legs beneath sheer-curtained windows. It is interesting to note that during this period it was stylish for the trim and doors in the room to remain unpainted. (Courtesy Tom Forkner.)

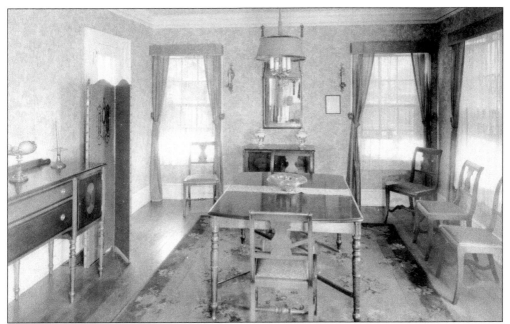

The photograph above features a view of the perfectly appointed dining room in the home of Dr. and Mrs. Isaac Catron. An inviting scene, highlighted by the Colonial Revival chandelier, it offered roominess without the sacrifice of a cozy atmosphere essential to the enjoyment of well-prepared meals. (Courtesy Tom Forkner.)

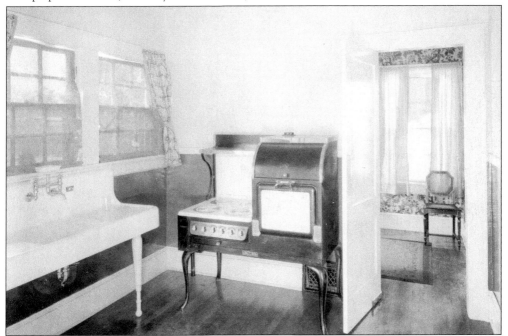

The type of model kitchen pictured above was a benefit for housewives in the 1920s. Although it is not a glamorous room, it is equipped with labor saving devices, such as a large sink and electric stove. The kitchen displays a practical arrangement, in spite of limited storage space. (Courtesy Tom Forkner.)

AUCT

233 RESTRICTED RESIDENCE
19 DISTINCTIVE

Avondale

At the Gates

ATLAN

Mon., Tues., Wed., Thurs. and Fri.
EVENINGS

ON

BUSINESS LOTS 233

MES 19

ɔtates

June 29, 30 - July 1, 2, 3.
AT 7:30

In October of 1929, America's great stock market crash set off a shock wave that toppled financial systems one after another. By 1931, the Great Depression had taken its toll on George F. Willis. A huge tent was set up along North Avondale Road, and lots sold for as little as $50. In a letter that appeared in the auction announcement shown here, Mr. Willis wrote: "The fact that hundreds of thousands of dollars worth of the finest improvements that money could buy have been installed, and that shrubs and trees and flowers, costing a substantial fortune have been planted, that residences and recreation facilities, costing additional hundreds of thousands are already part of Avondale, does not enter into the matter at all." (Courtesy Marion Reinhardt.)

59

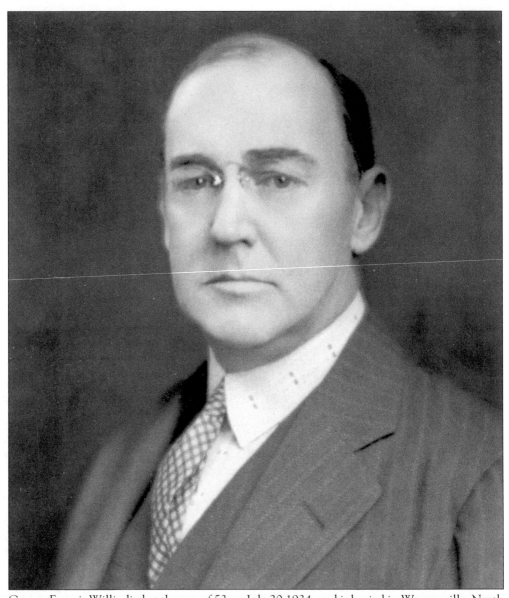

George Francis Willis died at the age of 53 on July 20,1934, and is buried in Waynesville, North Carolina. His individual charities were numberless, and his record is crowded with remarkable achievements. In 1928, he re-entered proprietary medicine with Sargon, still active in the company when he became ill early in 1934. Also in 1928, he accepted the presidency of the Stone Mountain Confederate Monumental Association at great personal sacrifice. In 1924, he founded Avondale Estates. In 1922, as chairman of Georgia Tech's finance committee, he spearheaded a $2 million fund-raiser. Mr. Willis' most prized possession, however, was a gold plaque presented by fellow workers at International Proprietaries, Inc. inscribed: That George Francis Willis may realize in a measure the appreciation of his organization for the privilege of association with a man of his sterling qualities, they have carved this message of love and esteem upon a tablet of gold, with the wish that it will ever serve as an emblem of prosperity and happiness. Christmas, 1920. (Courtesy Special Collections Department, Robert W. Woodruff Library, Emory University.)

Two

THE WARTIME YEARS

UNITED IN SERVICE TO COMMUNITY AND COUNTRY

"A man must have the stuff of success in him, must produce,
must work, must be capable, or he won't get to the top."

George F. Willis

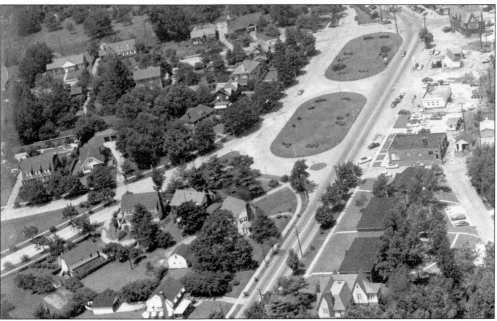

"One Thousand Acres of Paradise" was a headline often used to describe Avondale Estates in early media coverage. This 1940s aerial view of the city, as seen through the camera by Guy Hayes of Avondale, and veteran staff photographer for the Atlanta Journal and Constitution, captures the beautifully landscaped city, which continues to receive the highest praise from civic engineers and civic planning experts the world over. Experts praise the completeness in which all the elements of the city combine to make it an ideal place to live, from the standpoint of both health and happiness. (Courtesy Avondale Estates Garden Club.)

Ben Sands Forkner, Sr. (photograph by Thurston Hatcher), originally from Tennessee, was one of DeKalb County's most prominent citizens. In 1905, he married Bessie Allison of North Carolina. In 1912, they moved to Georgia, where he went into the dairy business, and was among the first to successfully grow alfalfa and crimson clover. In 1924, Mr. Forkner accepted George Willis' offer to become Superintend and General Manager of Avondale Estates. In 1933, he established Ben S. Forkner Realty, and remained active in community affairs. As chairman of the board of education of the Avondale district for 16 years, he helped turn one small country school into four modern institutions. A member of the Avondale Methodist church, he was superintendent of the Sunday school for 21 years. Mr. Forkner helped organize and served on the board of directors of the Decatur Building and Loan Association. He also served on the Executive Board of the Chamber of Agriculture and Commerce, and held the presidency for the Decatur Real Estate Board. Prior to his death in August 1948, a typical day in Avondale Estates would find the dignified Ben Forkner walking through town, greeting everyone along the way. (Courtesy Tom Forkner.)

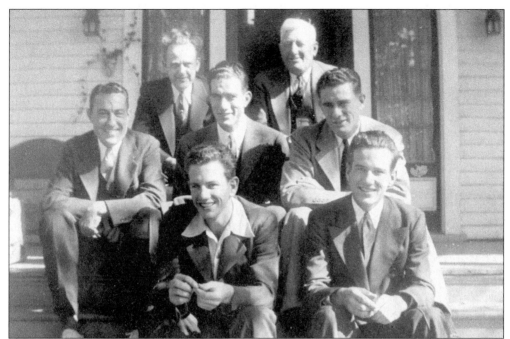

All the Forkner children, with the exception of Lawrence, were employed by Ben S. Forkner Realty, and sold Avondale properties. Pictured here on the porch of their two-story farmhouse on a Sunday afternoon in May 1944, are, from left to right, as follows: (front row) John C. Forkner and William C. Forkner; (second row) S. Lawrence Forkner, Thomas F. Forkner, and Ben S. Forkner, Jr.; (third row) G.X. Barker (brother-in-law) and Ben S. Forkner, Sr. (Courtesy Tom Forkner.)

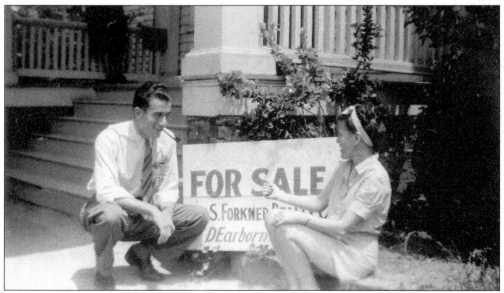

Tom Forkner and sister, Kathryn, are pictured above in a candid moment, laughing together at the footsteps of the farmhouse porch. In the background, the familiar Forkner Realty "For Sale" sign can be seen. Forkner Realty was responsible for a vast amount of both commercial and residential properties sold for decades throughout Avondale Estates. (Courtesy Tom Forkner.)

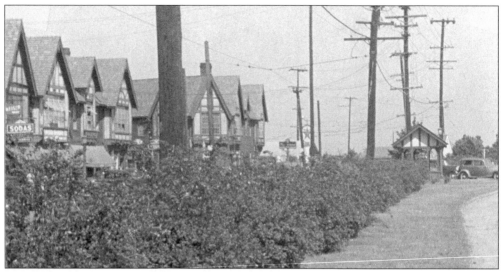

In 1932–33, a hedge consisting of 253 abelia bushes was planted along a three-block stretch of Avondale Road, adjacent to the streetcar line. In 1938, the Baron DeKalb Chapter of the Daughters of the American Revolution placed an historic marker near the west-end of the hedge to commemorate the Old Stage Coach Road from Augusta to Nashville. On March 5, 1975, the *DeKalb News Sun* reported that the abelia hedge was originally valued in 1965 between $35,000 and $50,000. (Courtesy Avondale Estates Garden Club.)

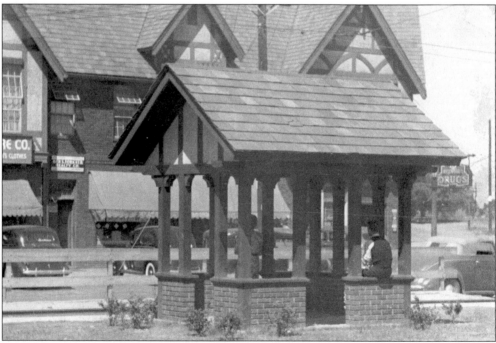

In 1935–36, the Avondale Estates Garden Club's beautification projects included a streetcar shelter at the end of the abelia hedge on the main plaza, at a cost of $231.50. The shelter, in later years, served as the first police station. In 1976, as part of the city's 50th celebration, a clock tower atop the shelter was dedicated, which stands watch over the city. (Courtesy Gerrill Kohn Shealy.)

A living Christmas tree was planted next to the car stop and decorated with lights for the first time in 1933. The cost of the huge evergreen at that time was a mere $25. Although the beautiful evergreen pictured above was replaced in the 1950s by a large holly; the lighting of the Christmas tree remains an annual tradition in Avondale Estates. (Courtesy Avondale Estates Garden Club.)

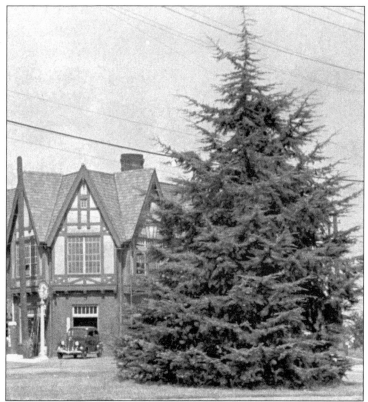

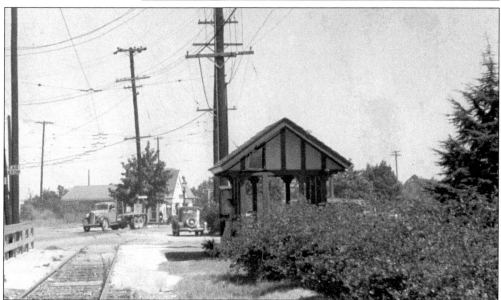

In the good old days, rapid transit in Avondale Estates was called the Stone Mountain streetcar. It ran along Avondale Road, where the abelia hedge is planted. The car was bright red, and its whistle could be heard for miles. A trip to Atlanta was quicker than a drive today, and Stone Mountain was only 20 minutes away. A paved bicycle path is now being laid, which follows the old streetcar route to Stone Mountain. (Courtesy Gerrill Kohn Shealy.)

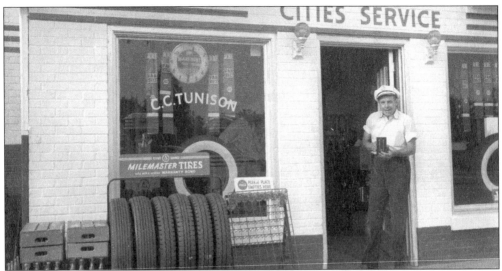

Charlie "C.C." Tunison opened Cities Service station in December 1936, when he began a 51-year association with the people of Avondale Estates. Pictured above, c. 1948, the walls of Tunison's then Tudor-style station were lined with historic photographs of the city. Longtime residents recall drinking Coca-Cola and exchanging stories of by-gone days. Among the memories shared, C.C.'s annual Christmas decorations are fondly recalled. (Courtesy Mrs. C.C. Tunison and Mike Parker.)

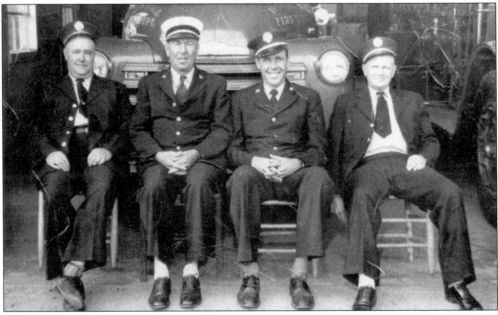

By 1947, Avondale had its own fire station, manned by the brawny firefighters above. Pictured, from left to right, in this 1949 photograph, are W.C. Shumate, Captain T.L. Fuller, G.G. Stafford, and R.L. Thompson. These men and associates (Captain Stephenson, W.L. Richardson, J.H. Dockery, and W.B. Massey), together with the Avondale Police force (Oscar Reid, Jimmy Davis and James White), repaired Christmas toys for the needy, a project spearheaded by Lt. Col. J.R. Hellams, city manager, and Mrs. Mary Lou Hurt. (Courtesy Henry Shumate.)

In 1938, the west-end two-story buildings, then home to the post office and city hall, became Avon Theatre. Here, the first Boy Scout Troop was organized. The 500-seat theatre presented live wrestling, boxing, and movies. J.M. Owens, blacksmith, once owned a home and shop here, which Willis had moved by mule and cable to the present site of Ray's TV. To this day, a cornerstone of the original hand-scripted marker reads: J.M. Owens, December 28, 1897 Settled Here. (Courtesy Marie Moon Stephens.)

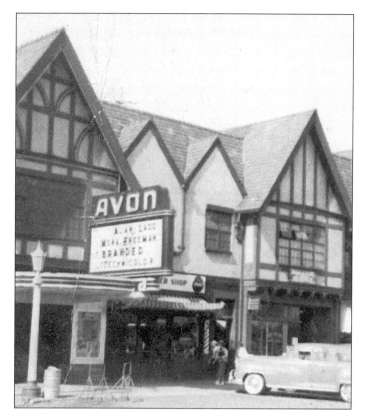

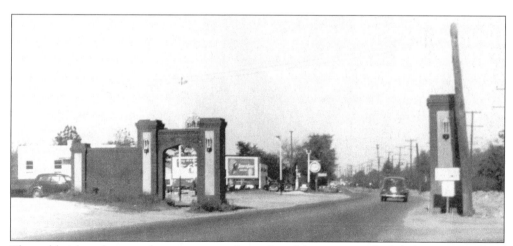

The red brick archway and gatepost on either sides of the street marked the west entrance of Avondale Estates. The single gatepost on the right, however, was torn down to facilitate road expansion. The left arched gateway still proudly stands as an age-old welcome. Surrounded by flowers year round, it is known as "Carl's Corner," named after an early gardener for the city. (Courtesy Avondale Estates Garden Club.)

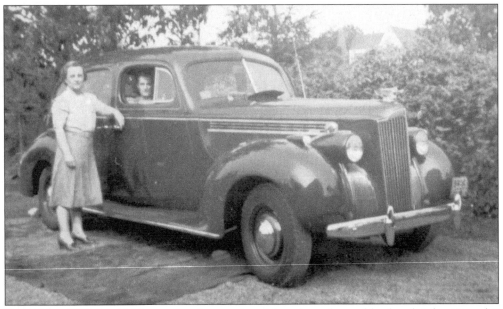

Bessie Mae Williams bid farewell to her mother (above), as she and husband, John "Speedy" head South from Buffalo, New York, in his buffed-up 1940s Packard.

This photograph presents a view of Stratford from Kensington. Stratford, a secluded dirt road surrounded by trees, was known as Lover's Lane. Bessie Mae and John were the third family to move in during August of 1948, when only five houses existed. Tom Forkner, who lived next door, sold them their house. There were no lights or phone service. The Williams' were delighted when Tom generously offered to run an electrical line from his house to theirs, until permanent lines could be installed. (Courtesy Bessie Mae and John Williams.)

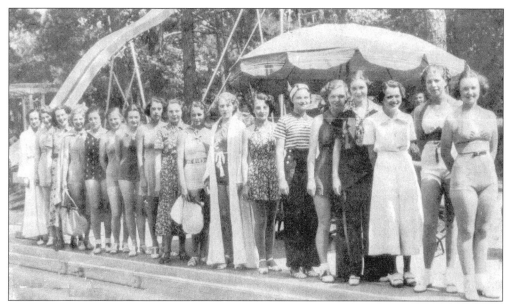

An elaborate 1930s fashion show was the highlight of Avondale Pool's Grand Opening that summer. The swimsuit models were local beauties. Those taking part were, from left to right, Misses Lilly Davis, Anne Lee Castles, Marion Reinhardt, Frances Jernigan, Rebecca Haynie, Gerrill Kohn, Ann Berney, Ann Edge, Dorothy Baumstark, Alyce Walker, Charlotte Behm, Mary Hill, Frances Chambless, Jean Sortore, Hortense Pounds, Dorothy Merritt, Beatrice Turner, and Hazel Oates. (Courtesy Marion Reinhardt.)

Bob Gross, c. 1948, can be seen with his prized 1939 Ford. Bob and brother, Ralph, were lifeguards from 1946–48, working seven days a week. As the only lifeguards on duty in 1948, they often slept overnight in the pool house, serving 160 hours a week. Bob and Ralph were servicemen when their father, Col. Felix E. Gross, moved into 79 Clarendon in 1943. Colonel Gross was mayor during the 1940s and early 50s, a path Bob would follow. (Courtesy Rutledge and Bob Gross.)

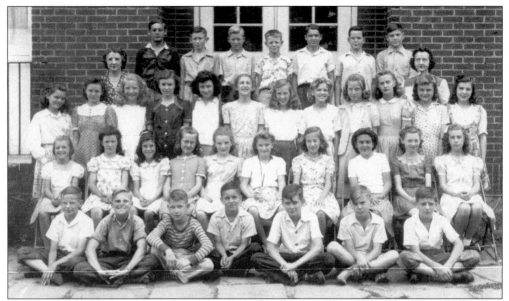

Members of the Avondale Elementary sixth grade class, circa 1942, are shown, from left to right, as follows: (front row) Jack Myers, Jerry Brand, Mayes Burgess, Danny Brineman, Scott Baxter, Walker Fife, and Bobby Burgess; (second row) Mary Ruth Wilson, Betty Wilkins, Johnny Ruth Williams, Bobby Joyce Lions, Mary Ben Erwin, Lonita Boddie, Jacqueline Leverett, Betty Ruth Henry, Jettie Chambers, and Merida Chandler; (third row) Mary Olson, Ann Hood, Lynne Leach, Joan Wingo, Mary Lee Smith, Dorothy Timms, Joyce Wood, Audrey Botsford, Betty Lou Samples, Eloise Burdette, Mary Beth Williams, and Lois Conquest; (fourth row) J.T. Bailey, Billy Gable, Harvey Hopkins, Billy Barnes, Leroy Slappey, Eugene Field, and James Sterling. Principal Mary Freeman, and teacher Mrs. Ivey are shown between the third and fourth rows on either end. (Courtesy Lynne Leach Gross.)

In 1944, Marian Garten and Lyman Murphey were crowned King and Queen of Hearts. In 1945, Avondale Elementary received the "Victory Flag" commendation from Governor Arnall for their war bond sales and other efforts. In 1949, upon returning home from a football game, Lyman was the victim of a fatal car accident, in which his younger brother, Red, was a passenger. Red Murphey has lived for 64 years in his boyhood home at 5 Clarendon, now with wife, Sidney. (Courtesy Rutledge and Bob Gross.)

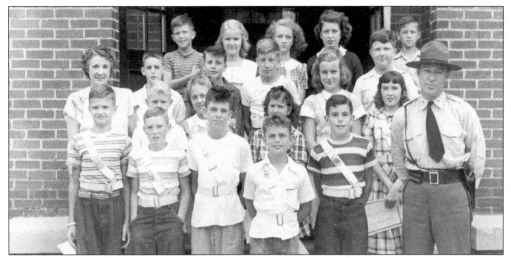

This photograph of "the nation's first" school patrol was taken on Inauguration Day, 1945. To promote *esprit de corps*, a decorated WWII Army officer stood with the patrol, and principal Mary Freeman. Pictured here, from left to right, are as follows: (front row) Bill Carthorn, Red Murphey, John Candler, Tommy Veal, Glower Jones, and the WWII Army Officer; (second row) James Botsford, Barbara Humphries, unidentified, and Lady Foy; (third row) Mary Freeman (principal), Alton Burdette, Jim Bocock, Bill Yarbrough, Joan Bailey, and Jack Krimmer; (fourth row) Buddy Hurt, Anna Avil, Shirley Dyer, Sally Perkins, and Bobby Clark. (Courtesy Glower Jones.)

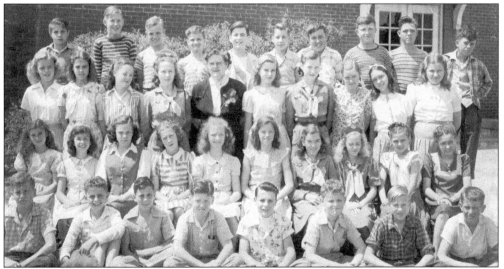

Members of this 1947 Avondale Elementary sixth grade class are shown, from left to right, as follows: (front row) Roy Hardy, Tommy Veal, Willis Hall, Bob Burgess, Jimmy Bocock, Jason Long, unidentified, and unidentified; (second row) Betty Ann Black, Carolyn Webber, Martha McCord, Hazel Hopkins, Joyce Rogers, Jerry Caldwell, Betty Ann Coryell, Doris Johnson, Emily Newton, and Barbara DeLoach; (third row) Marie Moon, Betty Joan Chatham, Elizabeth Allen, Billie Anne Rogers, Starr W. Cox (teacher), Joan Bailey, Kay Cooper, Betty Landra, Kathleen Williams, and Charlotte Etheridge; (fourth row) Edward Slappey, Elmer Cole, Bobby Judhan, Bill Carthorn, Tom Wadkins, Bill Yarborough, Jason Long, Jackie Kimmer, Royce Hardy, and Johnny Chandler. (Courtesy Marie Moon Stephens.)

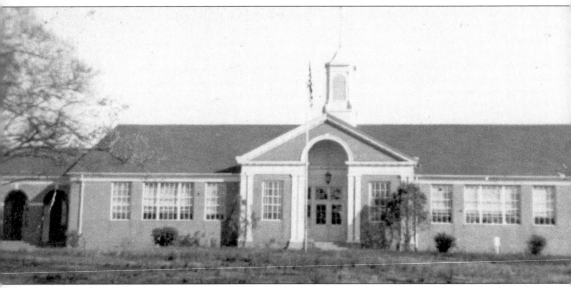

On October 9, 1937, bonds were again voted, this time in the amount of $43,000. This, along with a federal grant of $34,883, was used in part to build a high school on Old Stone Mountain Road. Completed in 1938, this was also the year that transportation of pupils began. In 1948, the Southern Association of High Schools accredited Avondale High. Physical education became a priority, and, in 1948, the new gym (opposite page) was added. In 1951, a new wing was added as a workshop and science laboratory. By then, Avondale High was among the nation's top-rated in sports and scholastics, particularly math. Mrs. Mary F. Lallerstedt, algebra and trigonometry teacher, was so revered that faculty and students dedicated the 1955 annual, *The Plume*, to her. During the 1954–55 year, about 650 pupils attended the school. On Monday, May 30, 1955, Avondale High School, consisting of 20 classrooms and an auditorium, was destroyed by fire. (Courtesy Marie Moon Stephens.)

After the fire of 1955, only the gymnasium above, with its locker rooms, basketball courts, tracks, baseball diamond, and football field remained. Avondale High School's reputation in sports, as a force to be reckoned with, gained momentum. The gymnasium was eventually torn down to make way for the Kensington Station of Atlanta's metropolitan rapid transit rail system, *MARTA*. The present day Avondale High School was dedicated on December 11, 1955; since then, several additions have been made. (Courtesy Marie Moon Stephens.)

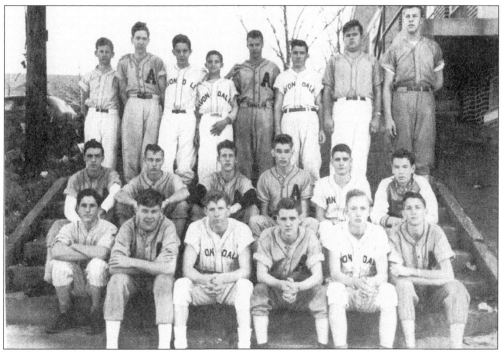

The photograph above shows the 1949 baseball team, featuring one of the school's most popular athletic seniors, Alton Adams. The 1949 edition of *The Plume* predicted Adams would be "the fifty fifth president of the United States." Pictured here, from left to right, are as follows: (front row) Bobby Hutson, Carl Watts, Alton Adams, Bobby Duren, Arnold Sasseen, and Lamar West; (second row) Charles Lockhart, David Hayes, Douglas Driver, Jake Bius, Marvin Norvell, and Frederick Tuck; (third row) Cornelius Moore, Paul Giles, Jimmy Pritchett, Milan Baldwin, James Ledbetter, Ronald Mize, William Biffle, and James Allgood. (Courtesy Marie Moon Stephens.)

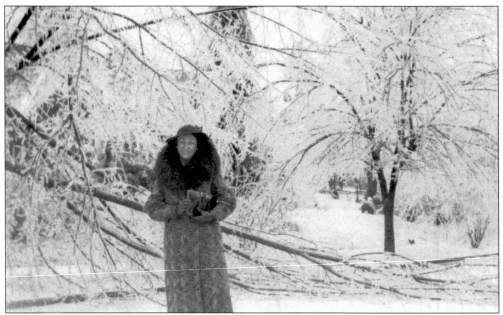

The year 1935 ended with an ice storm that paralyzed the city of Atlanta, and brought life to a virtual standstill for days. Sub-zero temperatures halted the trolley system, downed electrical power, and cut off phone lines, leaving Avondale Estates isolated in a world of its own. Here, on a brisk walk among the snow-covered trees of Dartmouth, Mrs. Claude Pyburn, wife of Mayor Pyburn, appears enchanted with the world around her. (Courtesy Marion Reinhardt.)

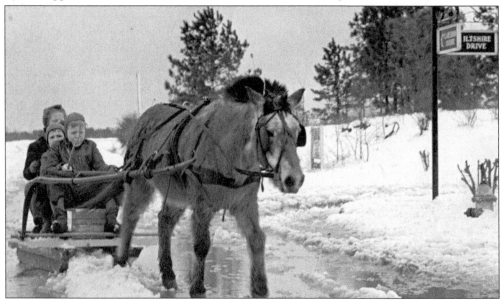

The milder snows of 1945 prompted the Leach children to hitch up their pony, and invite Glower Jones for a sleigh ride, shown here at the corner of Clarendon and Wiltshire. The Leach and Jones families lived across the street from one another and were among the first residents on Clarendon. Samuel L. Jones, Avondale's police commissioner, passed away in 1995. Sam and his wife, Alma, who passed away in 1999, lived in their home at 102 Clarendon for over sixty years. (Courtesy Glower Jones.)

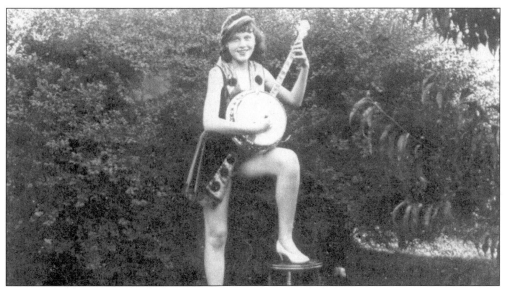

Perry Bechtel taught "Banjo Girl," Marion Reinhardt, shown here at age 14. Bechtel was a member of New York's famed Phil Spitalny's All Male Orchestra. In the mid-1930s, Marion was guest artist with Spitalny's All Girl Orchestra at The Paramount Theatre in Atlanta, and was later honored to play her one-and-only Bacon Silver Bell Tenor banjo for President Roosevelt in Warm Springs. (Courtesy Marion Reinhardt.)

Left: Gerrill Kohn is pictured in early 1930 at home on 67 Dartmouth. Her parents, Gerard and Sophie, purchased several Willis Estate lots and later built the house on 72 Dartmouth where they lived until the late 1970s. In 1942, Gerrill married James O. Shealy, U.S. Army Air Force officer; they purchased 75 Wiltshire, originally built by John Forkner in 1950, where she lives today. (Courtesy Gerrill Kohn Shealy.) *Right:* The little Dutch girl is Anna Avil (daughter of city commissioner, Don, and his wife, community activist, Elisabeth) in costume as one of the hostess daughters for the 1946 Annual Atlanta Tulip Festival, held at Hurt Park. A memorial dedicated to Elisabeth Avil, Joy Frontier, and Louise H. Ingram permanently rests near the Gazebo on Lake Avondale. (Courtesy Avondale Estates Garden Club.)

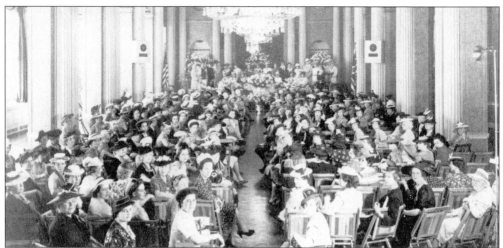

In 1944, the National Council of State Garden Clubs held their 15th annual meeting in the Atlanta Biltmore Hotel's Georgia Ballroom. The Avondale Estates Garden Club was selected as a hostess club for the prestigious event. Under the direction of Mrs. Byron P. Harris, president, Avondale club members created an extraordinary display of flower arrangements. To place the Avondale Estates Garden Club in historical perspective, the first garden club in Georgia was organized in Athens, 1889. The Garden Club of Georgia was founded in 1928, and The Avondale Estates Garden Club in 1931 at the home Mrs. P.J. McGovern, with 33 ladies in attendance. The club has honored Avondale's original landscaping plan and enhanced its progress, as decreed in Article II: "The object of this club shall be the advancement of gardening and the development of home grounds; to aid in the protection of forest, wild flowers and birds; and to encourage civic improvement." (Courtesy Avondale Estates Garden Club.)

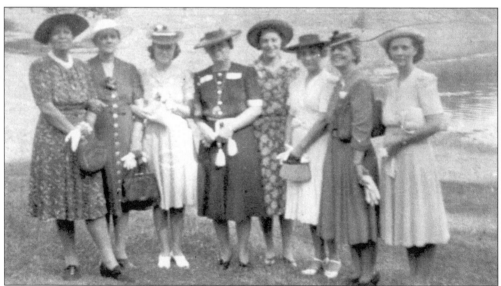

The Avondale Estates Garden Club celebrated its 10th anniversary with a rare gathering of all past presidents. Pictured at Lake Avondale, in order of tenure, from left to right, are Mrs. P.J. McGovern (who became postmaster in 1955), Mrs. J.E. McIntyre, Mrs. Byron Harris, Mrs. H.W. Goulder, Mrs. James C. Davis, Mrs. William Spitler, Mrs. E.B. Worsham, and Mrs. Lee A. Green. (Courtesy Avondale Estates Garden Club.)

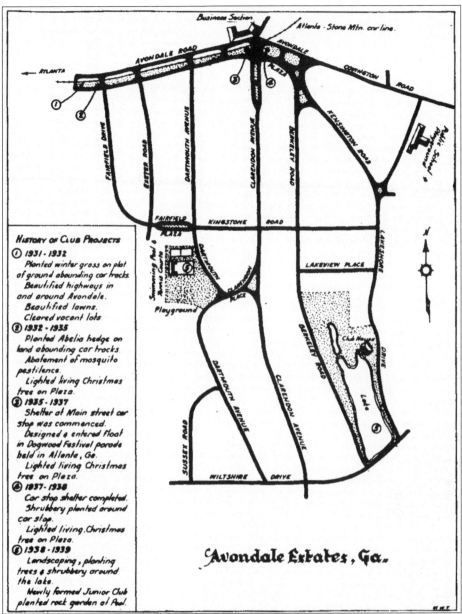

The Avondale Estates Garden Club map, hand-drawn in 1939, offers a diagram of main streets and a capsule history of club projects from 1931 through 1939. Under the presidency of Mrs. William Spitler, 1938–1939, the club adopted a major ongoing project, a living memorial to the city's founder, George F. Willis. At the Southern end of Lake Avondale, a place especially loved by Mr. Willis, a monument was proposed, with benches that would afford a sweeping view of the lake and clubhouse. On the south side of Wiltshire Drive, a bird sanctuary complete with birdhouses, feeding stations, and baths were planned for the area; eventually nature trails would wind in and out of the wooded area. On the clubhouse grounds and peninsula, plans called for 225 dogwood trees, 50 redbud, and 25 crabapple trees. At intervals along the lakeshore, weeping willow trees, and varieties of iris, jonquils, January jasmine, and other flowering shrubs would be permanently established over the years. (Courtesy Avondale Estates Garden Club.)

The Depression left many people jobless and homeless, but President Roosevelt's 1935 Workers Progress Administration (WPA) program provided thousands of Americans with work. With the help of the WPA, Avondale Estates landscaped the banks of the lake and surrounding land, clearing out the area on the south side of Wiltshire for the Willis Monument. The WPA was also instrumental in helping to install the city's historic abelia hedge at the west entrance of the city. Avondale Estates was one among thousands of cities nationwide to participate in President Roosevelt's WPA program. (Courtesy Glower Jones.)

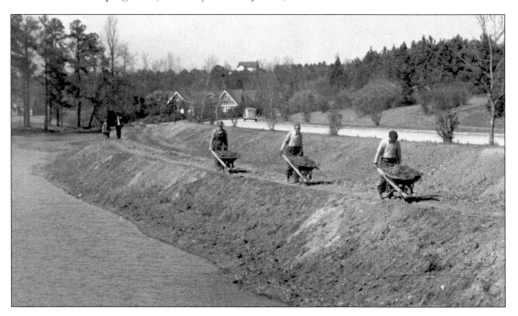

The above 1930s view, showing the west side of the lake viewed from Wiltshire (the east side view is shown below), sparks images of a time in Avondale Estates when resident equestrians could enjoy a morning canter or a brisk gallop at dusk. The open land and lakeside, improved by manual labor, is thought provoking. It is interesting to note that 8.5 million WPA workers assisted large cities and small towns nationwide. Six-hundred and fifty-one thousand miles of streets and roads, 78,000 bridges, 125,000 public buildings, as well as airports, public utilities, recreational facilities, and parks, such as those in Avondale Estates, were improved by the time the WPA was phased out in 1943. (Courtesy Glower Jones.)

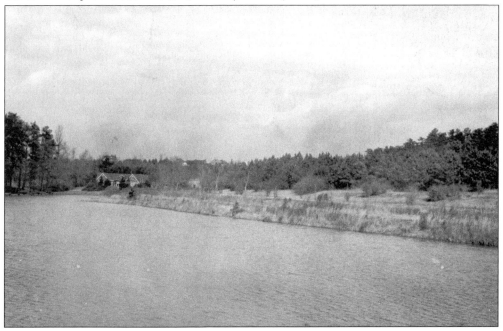

In April 1941, DeKalb draftees were honored in a ceremony in which the venerable Dr. W.H. Webb, who served in the Confederate army, attended. Sponsored by the Legion, UDC, and Draft Boards, the patriotic event, complete with marching band, included a speech by Judge James C. Davis, DeKalb Superior Court. Among the draftees inducted into the Army was Thomas F. Forkner, pictured here with parents, Ben and Bessie, who waited along with millions for news from abroad. (Courtesy Tom Forkner.)

In 1943, news that Lt. Ben S. Forkner Jr., age 29, of the U. S. Marine Corps, had been killed in the South Pacific devastated everyone who knew him. A beloved family member, accomplished student, and star athlete at Oglethorpe University, Ben received honors as fullback on the football team, as well as track and basketball. Family, friends, and comrades admired him, not only as an athlete and honorable Marine, but also as a man "of the highest character and mental attainments." (Courtesy Tom Forkner.)

On April 16, 1945, Thomas B. Bennett Jr., Captain in the Army Infantry, Military Intelligence, married lovely Betty Childs. The Lilly family had already moved from One Berkeley in Avondale Estates, and Betty's father immediately purchased it. He gave the Craftsman Bungalow to the newlyweds as a wedding gift; they lived there until 1999. After the war in 1946, Tom opened the first large manufacturing plant in DeKalb County, Bennett Furniture Company, in Stone Mountain. (Courtesy Betty and Tom Bennett.)

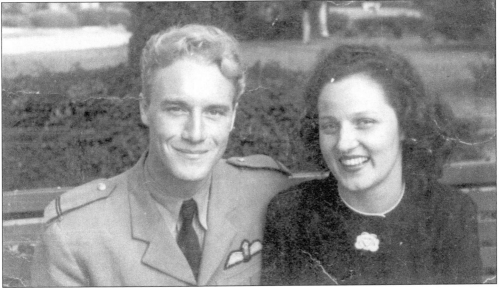

In February 1943, Denis Harry Payne, M.B.E., flight instructor and officer in the Royal Air Force, married Mary Clemon Daniel in Macon, Georgia. Denis was in training at Cochran Field in Americus, where both British and American cadets polished their war skills. Mary served as secretary to General Allan, who was stationed in London. After living abroad, the Payne's made Avondale their home in 1954. Mary was secretary at Stone Mountain Park for 25 years. (Courtesy Mary and Denis Payne.)

Bob Hope's USO Tour, "Les Brown and His Band of Renown," performed during the war years at Ft. McPherson. In response to Mr. Hope's search for a local celebrity, Marion Reinhardt was asked to join the show. Pictured above, Marion and guest are escorted via Army jeep to USO dressing rooms. Marion performed a Boogie-Woogie tap dance, with an encore of *Bye Bye Birdie* on the banjo. Mr. Hope included her on other Ft. McPherson shows continuing on into the Korean War years. (Courtesy Marion Reinhardt.)

During WWII, the *Reinhardt Review*, featuring Marion and several of her dance students, entertained 1,500,000 soldiers at Ft. Benning. The *Reinhardt Review* made over 1,500 appearances, and through their shows, raised over one million dollars in war bonds. Pictured above, soldiers swoon as Marion plays her banjo at the Parachute School in Ft. Benning. Backstage, the *Reinhardt Review* prepares for their upcoming performance. (Courtesy Marion Reinhardt.)

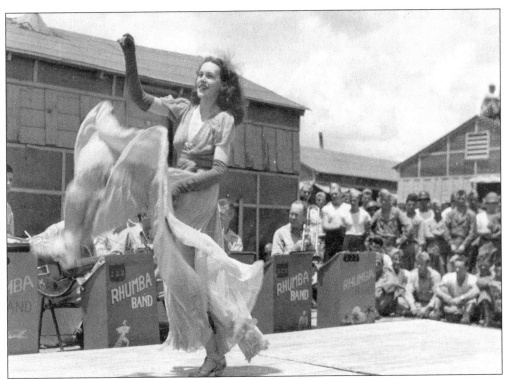

Pictured above in 1944, Marion danced the blues away in her choreographed version of *Tea for Two*, upon a makeshift stage at Ft. Benning, accompanied by the *Rhumba Band*. Soldiers even perched on rooftops for a view. "It was 110 in the shade," Marion recalls, "and we were performing for the troops in the noon sun. It was so hot that the glue on the bass player's instrument melted, and fell completely apart!" (Courtesy U. S. Army Signal Corp.)

Alluring pin-ups cheered lonesome GI's and boosted morale. Unknown to Marion, however, this pin-up was reproduced, and hundreds were bootlegged by an enterprising soldier who called himself, "Spicey Detective." Marion's talents were broad-based, indeed. In the 1940s, she choreographed *Oklahoma*; it was hailed as Ft. Benning's most ambitious theatrical project. An astounding success, Marion included several of her students in the show, and received rave reviews for her performance as *Laurie* during the dream ballet scene. (Courtesy U.S. Army Signal Corp.)

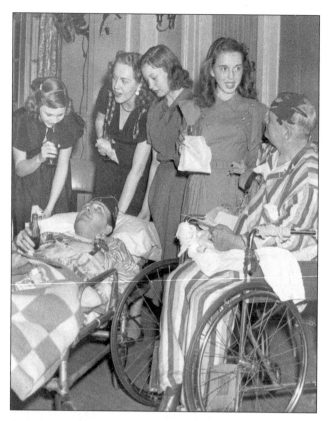

Marion and her students made frequent visits to V.A. hospitals, and sometimes performed for them throughout the year. Shown here on a visit during Halloween to the V.A. Hospital in Atlanta, from left to right, are Patricia Raoul, Marion Reinhardt, Betty Jo Hickman, and Isabelle Davies. Pictured below at the American Legion are Marion and her students in a *Merry Christmas* performance presented for underprivileged children, as well as members of the Legion, their children, and guests. Santa Claus made a special appearance after the show, distributing a bounty of gifts to all the boys and girls. (Courtesy Marion Reinhardt.)

As a teacher, Marion enjoyed helping students overcome their on-stage anxieties. Here, she was Master of Ceremonies in a performance by her students at the Moose Club in Atlanta in the early 1940s. Marion is seated at the piano with young students; Jan Jolly is at the microphone, accompanied by her brother on the accordion. The Perry Bechtel Trio (Marion's banjo teacher in her youth) was the featured entertainment at the Moose Club in the evenings. (Courtesy Marion Reinhardt.)

By the 1950s, Charlotte had travelled over 300,000 miles with her daughter, and made all her costumes. "Mama Reinhardt" accompanied Marion to New York in the 1930s for her season as a Rockette, and again to New York in the 1950s, when Marion auditioned for Arthur Godfrey. Relocation to California did not appeal to the Reinhardt's, and Marion continued her performances and dance studio classes in Georgia. She is pictured here on the beach with Marion for a 1940s Navy Show in Jacksonville, Florida. Charlotte passed away in 1977. (Courtesy Marion Reinhardt.)

This distinguished group of Avondale Community Leaders facetiously called themselves "The Dirty Eight," referring to their leadership roles in the "FFA" (First Families of Avondale). As city commissioners, the couples socialized monthly to discuss the needs of the city. Pictured here at the Hornibrook home on Dartmouth in the summer of 1948, from left to right, are as follows (sitting) Alma Jones, Inez Chaney, Bess Walker, Elisabeth Avil, Isabelle Hornibrook, Marge Buffington, Maggie Traylor, and Genevieve Spitler; (standing) Luke Chaney, Don Avil, Bill Buffington, "Doc" Walker, D.D.S., and Sam Jones; (sitting) Bill Spitler, Ned Hornibrook, Ned Traylor, and Ray Spitler. These citizens possessed the outstanding character traits that George F. Willis had imagined for the people who would make up his ideal city. As a testimony, in 1964, Avondale City Commissioners voted to designate the area north of the lake as "Bess Walker Park," in honor of her beautification efforts. Each lady made her own contribution, such as Alma Jones ensuring that needy children received dental care. During the war, the ladies worked as a volunteer Nurses Aides, caring for the wounded at Lawson General Hospital in Atlanta. (Courtesy Anna Avil Stribling.)

On a cold January morning in 1939, a young dynamic preacher named W. Arnold Smith delivered a soul-searching sermon to his congregation just outside of Avondale Estates. Here was a city of lovely homes, beautiful streets, excellent schools, parks, and playgrounds, but no church. That sermon set in motion the birth of the First Baptist Church of Avondale Estates. The May 30, 1947 groundbreaking photograph above shows many of its charter members. Seen here, from left to right, are as follows: (standing) Miss Vesta Osborn, Mrs. Louis Cook, Mr. E.E. Bocock, Mrs. Tom Lallerstedt, Mrs. Martha Settle, Mrs. Jack Osborn, Mrs. Ruby Roberson, Mrs. Arnold Smith, Mr. R.C. McHann, Mr. Tom Latham, Mr. Patterson, Emily Ann Smith, Pastor W. Arnold Smith, Mr. E.E. Steel, Mr. M.C. Farrar, Mr. Bill Turner, Mrs. Elizabeth Latham, Mr. M.M. Carroll, Mr. L.R. Potter, Mr. E.M. Loden, Mrs. B.W. Ford, Mr. J.T. Allen, Mrs. B.G. Barnes, Mr. L.R. Williams, and Mr. Welborn Reeves; (kneeling) Mr. Bradberry, Mr. Hunter Painter, Mr. H.A. Benong, Mr. J.F. Crowder, Young Jimmy Smith, Mr. C.L. Whorton, Mr. Roy White, unidentified, and Mr. C.N. James. (Courtesy Mary F. Lallerstedt.)

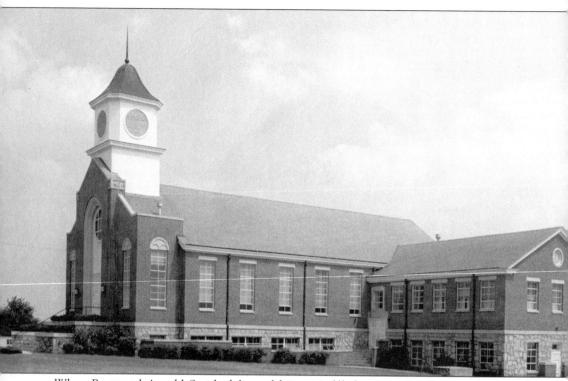

When Reverend Arnold Smith delivered his spirit-filled sermon on that wintry morning in January of 1939, he moved the hearts of his congregation to establish the First Baptist Church of Avondale Estates. With an authoritative voice, Reverend Smith cited from the Bible, II Chronicles 7:14: "If my people which are called by my name shall humble themselves, and pray, and seek my face, then I will hear from heaven and heal their land." The First Baptist church was organized in 1941, with 122 charter members. On June 1, 1947, the cornerstone was set. Until completion of the new church in 1947, however, the congregation met at Avondale Elementary School. The large, red brick two-story church represented two years of toil for its membership of 383. The pastor, deacons, elders, and laymen often worked until midnight. Many would come from day jobs, while their wives were on hand to serve coffee and sandwiches. In 1964, a new building was added, and then-Reverend J. Truett Gannon announced that the dedication service for the 800-seat sanctuary and education space, would be delivered by founding Rev. W. Arnold Smith. Today, under the guidance of pastor, Dr. Eric Mathison, the congregation numbers 1,222. (Courtesy Mary F. Lallerstedt.)

Three

THE FIFTIES AND BEYOND

LINKING THE PAST WITH THE PRESENT

"Life is too short to fool with peanut propositions." George F. Willis

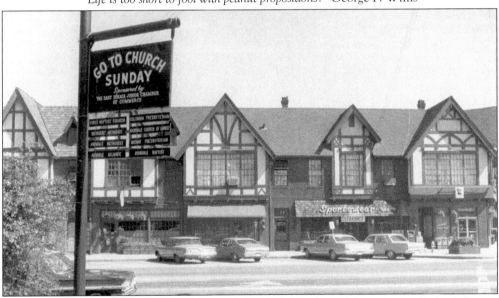

The "Go To Church Sunday" sign stands as a gentle reminder to keep a strong faith. A feature article on George F. Willis appeared in *Hearst's Sunday American*, June 3, 1928, in which reporter, Mildred Seydell, asked Mr. Willis if his parents, Jerkins and Emma Smathers Willis, were strict in rearing George and his two sisters. "I was brought up in good old Methodist fashion," Willis responded. "Sunday was the busiest day of the week for us. Starting with Sunday school, we went right through all kinds of meetings, ending with church service at night. The very worst whipping I got was for going swimming on the Sabbath." (Courtesy Avondale Estates Garden Club.)

This lucky horse, treated to a lick of ice cream, was legally just passing through. Avondale Estates had prohibited keeping live animals within city limits by the 1950s. On May 3, 1949, Mayor Felix Gross passed a city ordinance stating Avondale Estates had become so thickly populated that "the keeping of horses, cows, fowls, sheep, goats or other barnyard animals" was unlawful and detrimental to the city's well-being. (Courtesy Avondale Estates Garden Club.)

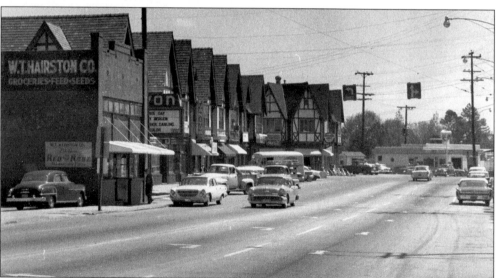

The 1950s ushered in a progressive era. In 1953, Mrs. Marietta Kneisley was elected the first female city commissioner, completing the term of the late D.L. Stokes. In 1954, a four-lane highway through Avondale to Decatur was constructed, the first patrol car went on duty, and Mayor Potter arranged for 35 new, more powerful streetlights. In 1957, the Avondale Woman's Club was founded, with its national motto: "Unity in Diversity." (Courtesy Avondale Estates Garden Club.)

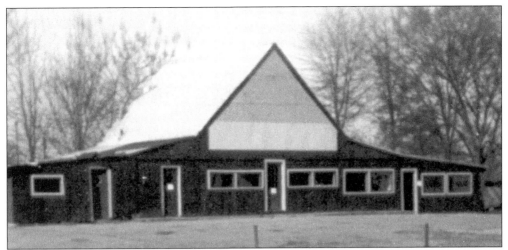

In 1921, Charles Goldie Jones took Jeanette Kelly as his bride, settling in Ingleside. Goldie used to walk to school with his cousin, True Freeman, son of J.T. Freeman, of one of Ingleside's first families. Goldie's father, A.K., was among the first automobile owners in DeKalb County and served as postmaster. Goldie and Jeanette owned the popular Avondale Tavern (shown above) for 30 years, situated west of the gates to Avondale. (Courtesy Marie Moon Stephens.)

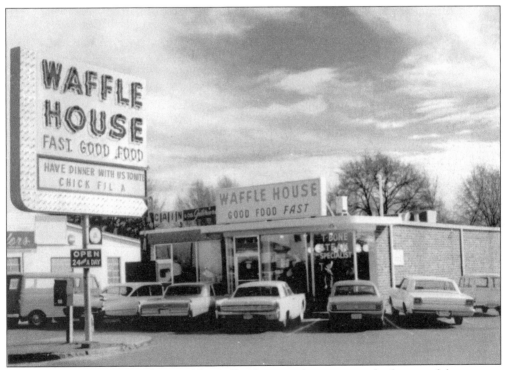

Both the first and the one-thousandth Waffle House in America were built west of the gates to Avondale. In 1955, the first Waffle House shown above (now Dragon East restaurant) was founded under the continuing leadership of Joe W. Rogers and Tom Forkner. In 1994, Waffle House was reintroduced to the Avondale area with its thousandth restaurant, built upon the old site of Goldie and Jeanette Jones' tavern. (Courtesy Tom Forkner.)

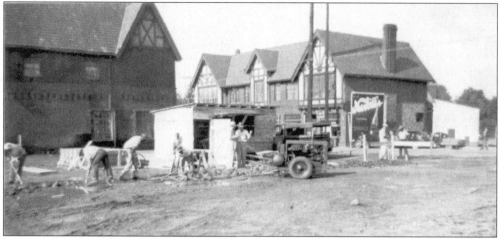

In the early 1950s, City Manager Hellams announced the building of Colonial Supermarket, measuring 100 feet long and 72 feet wide. Located at the site of the 1920s icehouse and present-day pharmacy, the above groundbreaking photograph depicts the $100,000 structure, offering the latest in refrigeration equipment, service counters, air conditioning, and the most novel feature of all—an incinerator which disposed of the day's refuse. (Courtesy Avondale Estates Garden Club.)

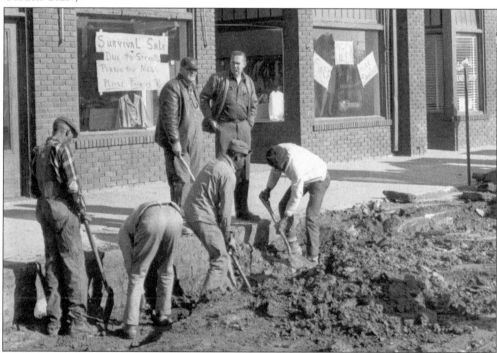

In July of 1954, Mayor Potter announced that part of the new four-lane highway running through the Avondale Estates business district would become six lanes in order to allow for parking. On August 19th, the DeKalb New Era announced that construction by the State Highway Department had begun, and that Avondale had completed the sidewalk on Old Stone Mountain Road. Today, work is again underway to extend the sidewalks of the business district. (Courtesy Avondale Estates Garden Club.)

In the late 1940s and early 50s, Charlie "C. A." Moon owned Avondale Restaurant. Charlie hired his wife, and daughter, Marie, as waitresses. Aunt Era Farmer was cook, and customers would often line up past the theatre just to get a table. In the 1940s, however, it sat vacant for many years due to one grizzly incident. Johnny Carnes and his paramour, Elizabeth Buice, entered arm-in-arm, taking a back booth. On the jukebox, Elizabeth selected "What is Life Without Love," turned to Johnny and, with her concealed gun, murdered him. Facing prison, she committed suicide. (Courtesy Avondale Estates Garden Club.)

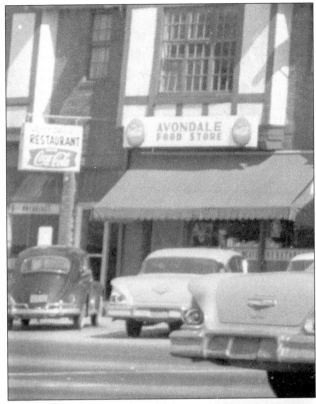

Preston Johnson went to work after WWII for Mr. Frances Hulme, then owner of Avondale Food Store. Preston and wife, Bert, later owned the small grocery store from 1964 to 1979. Offering free home delivery, the store attracted people from all over Atlanta to purchase Mr. Johnson's specialty meats. This September 1974 photograph shows the aftermath that occurred when a driver went to sleep at the wheel of his car, crashing through Avondale Food Store. (Courtesy Lallie Hayes.)

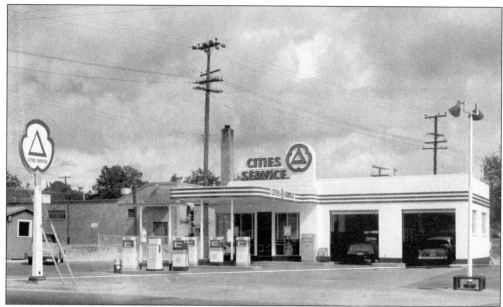

C.C. Tunison remodeled Cities Service in 1954, replacing the familiar Tudor style roof. The station kept its 1950s look until a final remodeling in 1963. Cities Service closed in 1987 and was later torn down to usher in the new Avondale Estates City Hall. George F. Willis' grandson and granddaughter, George F. Willis, III, and his wife, Kathy, and Helen Willis Ward attended the 1990 Dedication Ceremony. (Courtesy Mrs. C.C. Tunison and Mike Parker.)

On November 17, 1963, Mrs. Hazel W. Lawson, postmaster, presided over the dedication ceremony for the new 20,000-square-foot post office, marking the passing of a bygone era. It was a celebration, complete with the high school band, and a solemn occasion as well, with flag raising and the singing of the national anthem. Prominent guests included Postmaster General John Gronouski, Mayor Lee Potter, City Manager Dewey Brown, and the Reverend Truett Gannon. (Courtesy Avondale Estates Garden Club.)

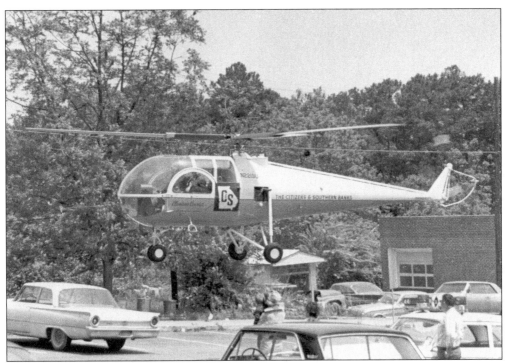

On October 1, 1961, Citizens & Southern Bank moved into its new building at Avondale Road and Oak Street, offering two drive-in windows, safe deposit boxes, and a 24-hour depository. City officials greeted officers of the bank arriving by helicopter at the Open House celebration. C&S was preceded, however, by the Citizens Bank of DeKalb as the first to offer drive-through banking to Avondale, with former postmaster Mac Farrar as teller. (Courtesy Avondale Estates Garden Club.)

When the city's original 1933 Evergreen died, Alton B. Langley, affluent businessman and resident of Avondale Estates, donated this towering Holly, and had it moved to its permanent location on Clarendon. Lighting the tree at Christmas has been an annual tradition since 1933. Dewey Brown is pictured (left) decorating the new Holly in December 1956, assisted by two unidentified elves. (Courtesy Lallie Hayes.)

Prominent city leaders were invited to a Christmas party at the home of Mr. and Mrs. Rae Hurt in 1957. Pictured above from left to right are Jay Wood, Peg Brown, Thelma Wood, Mary Lou Hurt, Alma Stone, Don Avil, Elizabeth Avil, D.L. Stokes, Mrs. D.L. Stokes, Noah Stone, and Rae Hurt. In keeping with the season of cheer, city leaders appear to be having a good laugh in the photograph below. Seen below, from left to right, are as follows: (standing) Noah Stone, Luke Chaney, Bill Spitler, and Dewey Brown; (seated) D.L. Stokes, Don Avil, Jay Wood, and Rae Hurt. (Courtesy Avondale Estates Garden Club.)

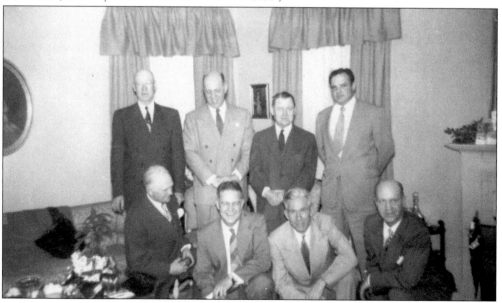

On July 1, 1974, Avondale Estates celebrated Noah Stone Day honoring his 80th birthday, and paying tribute to his service to the city. A World War One Army officer, Colonel Stone served for 37 years as City Attorney under seven mayors. He practiced law for over 50 years in Atlanta, and became Avondale's third City Attorney in 1942, passing the torch to A. Joseph Nardone Jr. in the 1970s. (Courtesy Avondale Estates Garden Club.)

Col. Felix E. Gross and wife, Edith Thompson, are pictured here in the rose garden of their home at 79 Clarendon. Colonel Gross, a career officer in the Army, purchased the home in 1943 and lived there 30 years. He served as Mayor of Avondale Estates during the 1940s and 1950s, when the city experienced a building boom. Edith Gross, a horticulture enthusiast, was former president of the Avondale Estates Garden Club. (Courtesy Lynne Leach Gross.)

In August 1969, the Board of Commissioners appointed Robert P. Gross, son of former Mayor Felix Gross, to fulfill the unexpired term of the late Mayor Lee Potter. He is shown taking the Oath of Office administered by city attorney, Noah Stone, and commissioners. Pictured here, from left to right, are Gordon Johnson, John Fletcher, Betty Beavers, Bob Gross, Judge Noah Stone, and Roscoe Lowery. Bob marshaled a campaign to prevent a 700-unit apartment development on the 52-acre Forrest Hills property, mounted a task force to ensure minimal impact of MARTA, and worked with DeKalb County on infrastructure changes to protect the city's plaza areas. Mayor Gross was also appointed Chairman of the 4th district of the General Municipal Association. Betty Beavers, Commissioner from 1967-1973, stated that under the leadership of Mayor Gross, "the Commission was truly reflective of the wishes of the citizens." Bob Gross was elected to a three-term office, but upon the advice of his physician, resigned in 1974. Mayor pro-tem John Fletcher assumed office. Commissioner Lowery summed up Bob Gross' administration saying, "He was a strong mayor, he gave this city direction when we needed it." (Courtesy Avondale Estates Garden Club.)

Rutledge Ingram married "the boy next door," Bob Gross. Both were second-generation members of Avondale and became parents to four children. The Ingrams moved to 56 Clarendon in 1941, and Rutledge was among the early equestrians to ride in the city's once-open fields. Her mother, Louise, was a noted artist. During Bob's mayoral term, Rutledge put her pen to paper, creating these fine drawings of Carl's Corner and the English Village, which became the city's stationery. (Courtesy Avondale Estates Garden Club.)

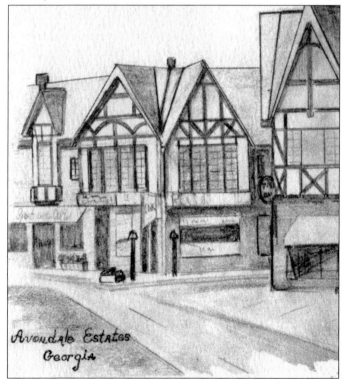

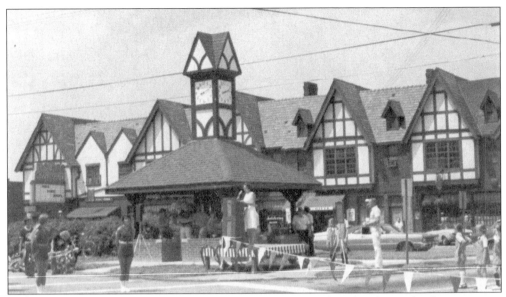

The city celebrated its 50th Anniversary, complete with marching band, parade of antique cars, and dedication of the Clock Tower at the old Trolley Car Stop. Coordinated by Marion Reinhardt, president of the Avondale Estates Historical Society, and city leaders, the fanfare was an event which hadn't been topped until Avondale Estates became host for the country of Poland during the 1996 Olympics. (Courtesy Avondale Estates Garden Club.)

In the 1970s, the city underwent a restoration to better define its English namesake, Stratford-Upon-Avon. City Commissioners Betty Beavers, Claudia Lowery, and Jean Leslie headed the Restoration Committee. Pictured here are Rutledge Gross and Jean Lorentzon, committee members, who helped install window boxes, Old English lettering on window fronts, hanging baskets of flowers, and hand-painted wooden signs for each store. (Courtesy Pat Frontier Maddox.)

The Avondale Estates Garden Club Officers for 1962-63 prove they are working members of their beautification projects. Pictured here, from left to right, are Ruth Connell, recording secretary; Kim Langhorn, second vice president; Harriette Haller, president; Elizabeth Sizemore, first vice president; and Thelma Wood, parliamentarian. Memory trees are planted throughout Avondale. This administration planted a weeping cherry honoring the late Edith Spencer, and a flowering peach tree honoring the late Mrs. Simpson Foy. The club members not only donned gloves and shovels, but also possessed true artistry, as shown in this graceful, award-winning Calla Lilly arrangement created by Mrs. Foy for the 1955 Annual Flower Show. (Courtesy Avondale Estates Garden Club.)

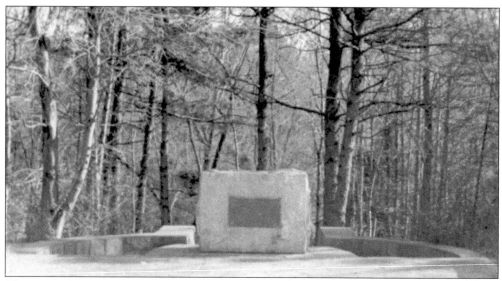

This monument was dedicated in ceremony to George F. Willis on May 1, 1940, inscribed: "The Avondale Garden Club dedicates the beautification of Lake Avondale and Bird Sanctuary as a scenic and living memorial to George Francis Willis, Founder and Developer of Avondale Estates, 1940." When Mr. Willis' grandchildren performed the unveiling, the forest was very young. This 1950s photograph, however, reveals a mature sanctuary, offering a year round symphony of birdsong. (Courtesy Avondale Estates Garden Club.)

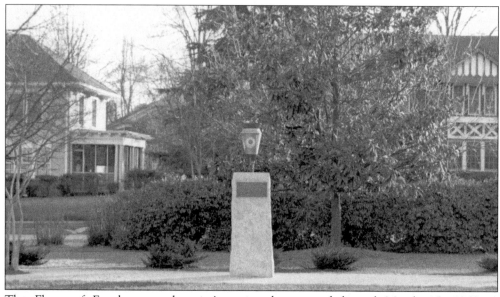

The Flame of Freedom on the city's main plaza was dedicated March 15, 1969 in commemoration of the American Legion's 50th anniversary, and is "dedicated to all those who served the cause of freedom in the armed forces of the United States." The monument is situated on a base of gravel, and flanked on either side by a towering flagpole and a well of juniper trees. (Courtesy Avondale Estates Garden Club.)

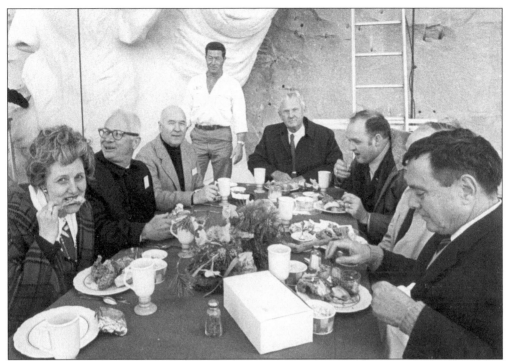

Fifty-five years elapsed from 1915 when Borglum submitted his original sketches, until its completion by Roy Faulkner in 1970. "Not a blow of the hammer was struck" for 36 years, from 1928 to 1964. On March 23, 1970, the Stone Mountain Memorial Association hosted approximately 70 members of the news media at a luncheon atop the carving prior to the dedication. Board members, shown above, descended the mountain via handmade conveyance, to a table perched on the shoulder of General Lee. Pictured here, from left to right, are Mary Payne, Executive Assistant and Secretary; Thomas A. Elliott, General Manager of the Park; Col. William L. Kinney, Assistant Manager of the Park; Honorable Ben W. Fortson, Jr., Secretary of State; Honorable Thomas T. Irvin, Commissioner of Agriculture; Dr. Lane Mitchell, Georgia Tech; and Honorable Arthur K. Bolton, Attorney General. Roy Faulkner, Chief Carver, is standing. Twenty-thousand guests attended the dedication, including the Vice-President of the United States Spiro T. Agnew and his party, shown below arriving by helicopter flying directly in front of the carving. The carving of Jefferson Davis, General Robert E. Lee, and General Stonewall Jackson is larger than a football field. (Courtesy Mary Payne.)

Bennett Furniture Company in Stone Mountain kept builder, owner, and retired Army Capt. Thomas B. Bennett, busy at the saw, as seen above. Bennett Furniture cut timber from their land, ran it through the sawmill, put it through a dry kiln, created the furniture, and shipped to all parts of the Southeast in their own trucks. In 1962, the factory burned to the ground, an episode shrouded in mystery. Tom and Betty, while living at One Berkeley, dug out the basement, built an intricate brick fence with help from neighbor, D.L. Stokes, and also added a large, brick three-car garage. Tom Bennett owned several lots in Avondale, and built the ranch style house at 16 Berkeley, shown in the corner below. (Above courtesy Tom and Betty Bennett; below courtesy Avondale Estates Garden Club.)

After Tom P. Samford and his wife, Corinne, built their home at 890 Stratford Road in 1951, Tom later dedicated his talent to Lake Avondale in the 1970s with a cherished Gazebo, and, in the 90s, with a beautiful arched bridge and floating Christmas tree, complete with lights, for the holidays. Shown above in 1953 are the Samford children, Pam, Tom, and Bill, enjoying their backyard pool with neighbor Barbara Gordon. (Courtesy Tom and Corinne Samford.)

C.C. Tunison's daughter, Mary Virginia, is pictured in the driveway of their home at 145 Covington Road in May 1956, waiting for her beau and future husband, Lewis Parker. Mary and Lewis Parker married in July 1956, and had one son, Michael Lewis Parker. Mike Parker still lives in the Avondale Estates home of his childhood. (Courtesy Mike Parker.)

Harriette Haller is pictured in 1953 with young son, Forrest, surrounded by the ducks at Lake Avondale. Harriette and Bob purchased 95 Berkeley, complete with lakeview, while it was still under construction in 1950. The Haller property was beautifully landscaped by prominent Atlanta landscape architect, Edith H. Henderson, FASLA. Bob worked to place Avondale Estates on the National Register of Historic Places through meetings with Sen. Sam Nunn in Washington. (Courtesy Bob and Harriette Haller.)

In December 1958, Forrest Haller (shown second from right) and troop members received their awards in a ceremony at City Hall. At that time, City Hall was located on Clarendon at the present site of Nancy's Florist. For many years, the scouts met at various locations in the city. The scouts now have their own hut, tucked in the forest on Lake Avondale. (Courtesy Bob and Harriette Haller.)

The Frontier children, Mary, Phil, and Pat are shown here in 1950. Joy and Al Frontier moved into One Fairfield Plaza in 1948 from Chicago, with Joy's mother, Maude McNamara. Joy and Maude, expert seamstresses, created garments for the family, including Pat's showy Betsy McCall doll with its miniature replicas of the girls' actual handmade ballet costumes. All the children were members of the Avondale Swim Team. Philip Frontier became a city commissioner in the 1970s. (Courtesy Pat Frontier Maddox.)

Tom and Betty Bennett parented five children, Beth, Bert, Ann, Mary, and Bill. Like many children in Avondale Estates, three of their five children took dancing lessons from Miss Marion Reinhardt. Pictured above in the driveway of their home at One Berkeley is Bert in his vintage toy automobile, and curly-haired Beth posed on her tricycle. (Courtesy Tom and Betty Bennett.)

Journalist Bettyann Lingle was a correspondent for the *DeKalb New Era*; she covered all the news of Avondale for several decades. A resident and mother of five, Bettyann was active in the community and was president of the P.T.A. Bettyann received Atlanta's "WSB Award" for her work with Vietnam servicemen. For years, she wrote letters of encouragement, sent cookies, shopped, and mailed packages to soldiers she had never seen. Bettyann's son, Gerry, also served in Vietnam. (Courtesy Lallie Hayes.)

Guy Hayes, 50-year professional photographer with the Atlanta Journal and Constitution, lived in Avondale Estates from 1949 until he passed away in 1998. Guy married Dottie Merritt, who grew up in the house on 82 Clarendon, and they became parents to a daughter, Lallie. Guy Hayes photographed many of the images appearing in this book. He faithfully documented the growth of Avondale Estates as it unfolded. (Courtesy Lallie Hayes.)

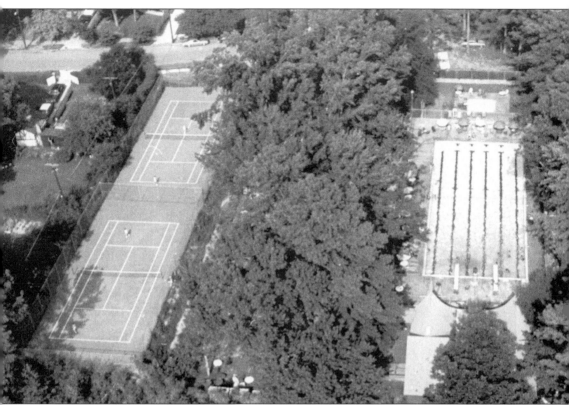

Guy Hayes captured this 1971 soaring view of the Avondale Community Pool and Tennis Courts. In 1975, tennis players dusted their rackets, but headed to city hall. The time had once again come to resurface the courts. The Community Pool Board, with Phil Frontier as president, came up with a solution. Using creative financing, two new championship courts were added in the mid-1970s and became part of the private pool membership. The original tennis courts, open to the public, received a recent facelift in 1998. In the 1950s and 1960s, the pool became the center of attention with its annual swim meets. Over 1,000 swimmers belonging to the Amateur Athletic Union (AAU) traveled throughout the Southeast to compete in various cities. From 1956 to 1963, the Avondale Swim Team participated in the competition and hosted its annual "Dixieland Championships." Bleachers were set up and parking space was prepared for the 1,000 swimmers and fans, who flocked to the city to cheer their teams. (Courtesy Avondale Estates Garden Club.)

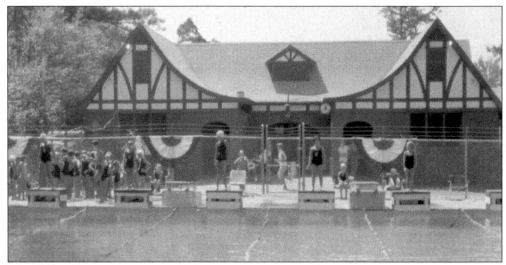

The 1956 AAU team received high praise in the press for the meet held at the Avondale Community Pool in August. The *DeKalb New Era*, August 30, 1956, reported "the AAU gave the local meet top billing and proclaimed it the most outstanding held in the Southeast this year." Among the competitors shown on the starting blocks above are seven-year old Cindy Munroe and eight-year old Pat Frontier, who still makes Avondale Estates her home. (Courtesy Pat Frontier Maddox.)

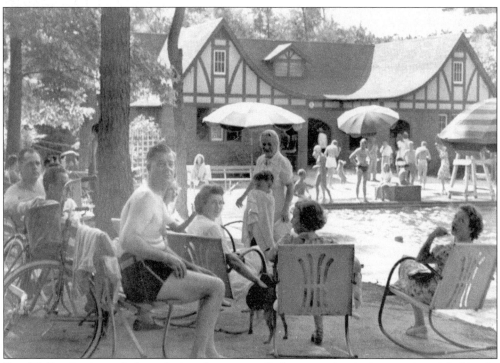

Doc Walker is pictured above facing the camera. Relaxing and enjoying a swim with friends, the photograph appears to have been taken before additions were made to the poolhouse. Starting blocks in the distance also suggest there may have been a swim meet that day. (Courtesy Avondale Estates Garden Club.)

The 1958 Avondale Swim Team brought home five team trophies, four new Georgia AAU records, and some 90 individual medals, dominating the Queen City Championship meet in Gainesville, Georgia, on June 27-28. Appearing here, from left to right, are: (front row) Margie Wills, Cindy Munroe, Virginia Dwen, Sandra Cochran, Andrea Allen, and Susie Zierath; (second row) Pat Frontier, Martha Knudsen, Mary Frontier, Jimmy Chapman, Courtney Wall, Mike Pitts, and Paul Senkbeil; (third row) Tommy Senkbeil, Steve Wall, Lee Bradford, Mike Wall, Kay Weede, Ted Wills, and Ricky Ryer; (fourth row) Barbara Pitts, Roberta Henry, Bunny Bergin, Rhodes Bradford, and Greg Rattray; (fifth row) Palmer Yeaple, Phil Frontier, Bill Hargett, John Fletcher, and Phil McMillan. (Courtesy Pat Frontier Maddox.)

Coach Calvin Ramsey and Avondale Estates will go down in sports history as being synonymous. From 1951 to 1969, Coach Ramsey led Avondale High School's football team, the Blue Devils, to legendary heights. During his last 12 years as coach, his teams were consistently victorious, never losing more than one game a year. His 167-wins ranks second in DeKalb County's history. Enshrined in the Georgia Sports Hall of Fame in 1998, Ramsey posted a 167-33-8 record, a DeKalb county best. Reverend Truett Gannon, former pastor of Avondale Baptist church, was chaplain for the team during Ramsey's celebrated tenure, and recalls that Ramsey always found time to teach Sunday School, and "taught us that when you lose, you should keep living and moving on." Calvin Ramsey was a graduate of Mississippi State University and a WWII Navy veteran. Married for 52 years to wife, Helen, they parented five children. Calvin Ramsey, 74, passed away on August 24, 1999. Presiding Reverend Mathison described Ramsey as "more than a coach...a teacher, a motivator, a leader and a role model." The huge turnout for Ramsey's funeral included many of his former players. (Courtesy Marie Moon Stephens.)

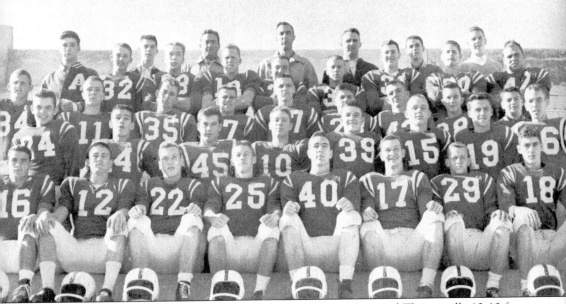

In 1958, under the leadership of Coach Ramsey, the Blue Devils untied Thomasville 13-13 for the state title. Shown above, from left to right, are Varsity Team members: (first row) Jit Reinhardt, Frank James, Eddie Polley, Billy Deal, Kit Bell, Bill Dahlberg, Hugh Duncan, and Larry McLendon; (second row) Tommy Wolfe, Mark Thompson, Richard Roller, David Browning, "Charlie Horse" Jones, "Ditto" Thomas, Andy Wiley, and Freddie Guy; (third row) Bill Lash, Albert Grizzard, Larry Pearson, Jerry Owens, LeRoy Garner, Calvin Lott, Tommy Robinson, Jon Henson, and Mike Herron; (fourth row) Edwin Pritchett, Merrill Dye, Neil Passmore, Phil Frontier, Stanley Hunt, Jim Popp, Jimmy Waldron, and Stanley Bell; (fifth row) Manager Chris Wren, Coach Harry Logue, Coach Calvin Ramsey, Coach Tifton Goza, Manager Johnny Fletcher, and Manager "Tonto" Coleman. (Courtesy Marie Moon Stephens.)

James William Anderson, III, graduated from Avondale High School in 1955. The prophetic caption beside his photo in the *Plume*, was scripted "Born for success he seemed." In his high school years, Bill served as editor of the Plume, class president, pitched for the 1954–55 baseball team, and played on the football team. Bill was also a member of the "A" Club, 4-H Club, and the Quill and Scroll. (Courtesy Bill Anderson.)

Appropriately voted "Most Likely to Succeed," Bill Anderson had his own band even in high school. Shown here is his popular local band, "The Avondale Playboys," *c.* 1953. From left to right, are: (front row) Jerry Jones, Bill Anderson, and Charles Wynn; (second row) Billy Moore and Jimmy "Meatball" Bell. (Courtesy Bill Anderson.)

Bill Anderson made history with his first song, "City Lights," written while employed as a disc jockey in Commerce, Georgia. At the time, he was still in college at the University of Georgia in Athens (where he also worked for a while as a disc jockey), and received a degree in journalism, majoring in television and radio. In 1958, "City Lights" climbed to #1, prompting Decca Records to sign Bill to a recording contract, and the City of Commerce to name a street in his honor. Upon graduating college in 1959, Bill moved to Nashville, where he contracted with the Grand Old Opry, and signed an exclusive agreement with leading talent agent, Hubert Long. (Courtesy Bill Anderson.)

By 1963, Bill was America's #1 male country singer and songwriter. His half-hour "Bill Anderson Show" appeared to millions of television viewers nationwide during the 1960s, featuring "Whispering Bill" and his band "The Po' Boys," shown here. Seated is "Whispering Bill" Anderson; "The Po' Boys," standing, from left to right, are Weldon Myrick, steel guitar; Jimmy Gateley, fiddler and bass player; Len "Snuffy" Miller, drums; and Jim Lance, lead guitar. Bill Anderson is host of "Backstage at The Grand Old Opry," broadcast on Saturday nights, 8 p.m., on Nashville's TNN. (Courtesy Bill Anderson.)

The Young Teens Club and their dates are pictured above at the 1955 formal Christmas Dance. The club was made up of students, who sponsored dances after the games and undertook welfare projects to help the needy. Pictured here, from left to right, are (front row) Martha Williams, Sonya Buford, Jane Chastain, Pat Chandler, Ann Douglas (President), Mary Ann Mahon, Vicki Hurt, Betty June Weede, Mickey Stephens, and Marsha Vineyard; (second row) Ralph Adams, Norman Bush, Wayne Turner, John Chandler, Alton "Rocky" Adams, Roy Humphries, Loren Bloodworth, Sam Taylor, M.C. Yarborough, and Tommy Catron. (Courtesy Rocky Adams.)

Alton "Rocky" Adams, star athlete of the class of '49, began a courtship with Virginia Ann Douglas, class of '55. Ann was an active student, serving as sports editor of the *Plume*, majorette, member of the basketball and softball teams, president of the Young Teens Club, and member of the 4-H Club were among some of her high school activities. Shown here in 1956, Ann Douglas and husband, Rocky Adams, celebrate his racing victory in Chapel Hill, North Carolina. (Courtesy Rocky Adams.)

Rocky Adams began racing in 1954 with the Southern Midget Racing Association, professionally competing at the Lakewood Peach Bowl in Atlanta and throughout the Southeast. The photograph above shows Rocky in his winning Sprint Car with trophies. Rocky competed with four-time Indianapolis winner, A.J. Foyt, back when Foyt was just beginning to make his mark in the racing world. Rocky and his racing buddies built and repaired their own cars. Shown below, from left to right, are Rocky Adams, Bobby Burgess, Ralph Blalock, and Lloyd Melton. Rocky began working with Lloyd "Flea" Melton in 1948 while still in high school. He served in Korea for four years, and returned to Avondale, married Ann Douglas, and began his racing career. Flea and Rocky resumed their working relationship at Southeastern Plumbing and raced competitively. When Lloyd Melton passed away the late 1980s, Rocky Adams acquired controlling interest in Southeastern Plumbing. (Courtesy Rocky Adams.)

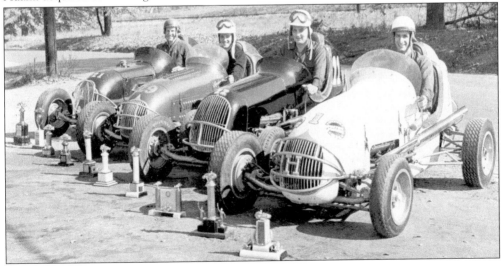

The original footbridge at Lake Avondale, spanning the northwest fork of the waters to Bess Walker Park, was built in the early 1950s. By the end of the 1960s, however, the bridge was in a serious state of disrepair. Roscoe Lowery, City Commissioner, President of the DeKalb Municipal Association, and Judge Advocate General of the Georgia National Guard, recognized the need and arranged for a new footbridge. Company B of the 878th Engineer Battalion of the Georgia National Guard, commanded by Captain Edward Milam, is shown above hard at work. A weekend project, the bridge was built under the Helping Hand Program, created to assist communities and provide on-the-job training for the National Guard. The 1960s bridge remained until 1996, when Tom P. Samford replaced it with the present gracefully arched structure complete with handrail. Shown below is young James O. Shealy Jr. crossing the original 1950s footbridge. (Above courtesy Avondale Estates Garden Club; below courtesy Gerrill Kohn Shealy.)

What could be more fun on a summer day than to feed the ducks and wet your hook in the picturesque surroundings of spring-fed Lake Avondale? A delightful experience on its own, but when combined with the English Tea Festivals of the mid-1970s, the fun turned to fanfare and fund-raising, including a trophy for the largest fish caught. The day-long event featured ladies dressed in English attire serving tea and goodies, but also hot dogs for the kids. Music, complete with folk ballads and bagpipes, accompanied dance performances by Marion Reinhardt's talented students. Arts and crafts booths were plentiful, with needlework, cornhusk dolls, patchwork pillows, candle-dipping, stationery, cookbooks, bake sales, ceramics, face-painting, and more. There was even a dunking booth in which fearless city leaders were targeted. Proceeds from the English Tea Festival went toward further restoration of the parks and playgrounds, and general maintenance of the city. (Courtesy Avondale Estates Garden Club.)

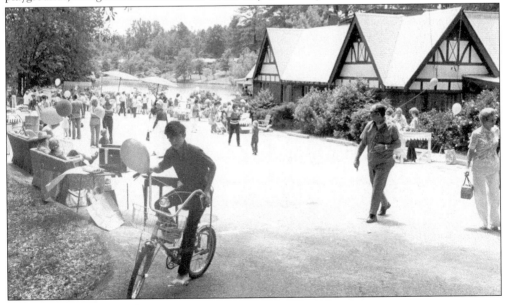

In this mid-1960s photograph, City Commissioner Don Avil and his wife, Elisabeth, hosted a reception, which included city leaders and their wives. The celebration was in honor of the Golden Anniversary of Don's parents, Frank and Anna Avil. During the Depression years, Don and Elisabeth Avil brought his parents from Philadelphia to live near them in Avondale Estates. Pictured above from left to right are: (front row) Inez Chaney, Meg Traylor, Isabelle Hornibrook, and Genevieve Spitler; (second row) Elisabeth Avil, Don Avil, Frances Fox Van Duesen, Frank Avil, and Anna Avil. The Community Club has hosted thousands of events, including club meetings, seasonal parties, weddings, and theatre troupes, such as the old Avondale Minstrels and the popular Avondale Estates Community Theatre's lavish production of William Shakespeare's *I Will*, also invited to perform in England, Scotland, Ireland, and Wales. Interestingly, the tour ended with special showings in Stratford-Upon-Avon, the city's noble namesake. (Courtesy Anna Avil Stribling.)

The Gazebo at Lake Avondale nestles in the trees along the peninsula. Designed with bench seating around its interior walls, the scenic location has served as a cathedral for weddings (including the author's), a stage for musicians, and other ceremonious occasions. The octagon-shaped structure, with cedar shingle roof, measures about 16 feet in diameter with a 20-foot ceiling. Tom P. Samford designed and built the Gazebo as a gift to the city. (Courtesy Avondale Estates Garden Club.)

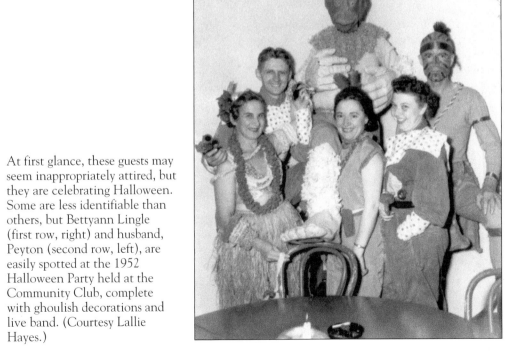

At first glance, these guests may seem inappropriately attired, but they are celebrating Halloween. Some are less identifiable than others, but Bettyann Lingle (first row, right) and husband, Peyton (second row, left), are easily spotted at the 1952 Halloween Party held at the Community Club, complete with ghoulish decorations and live band. (Courtesy Lallie Hayes.)

121

A sheet of ice became the dinner table for the ducks at Lake Avondale. The city could not escape being caught in the jaws of a cold wave that moved through a majority of the country in the early1970s. (Courtesy Avondale Estates Garden Club.)

It didn't happen often that the lake froze over, but when it did, the ever-present ducks were at the mercy of good-natured citizens for their breakfast, lunch, and dinner. The snow soon turned to slush, and children are shown, gathered near the shore with buckets of fuel for their hungry feathered friends. (Courtesy Lallie Hayes.)

A young boy laces his skates in anticipation of a chilling thrill atop the frozen lake. (Courtesy Lallie Hayes.)

Lake Avondale has only been drained twice, according to long-time residents. But when the day arrives, it is unsettling not only to the citizens, but also to the ducks. In August of 1970, the draining of Lake Avondale revealed ancient surprises. This Guy Hayes collection depicts the photographic journey of a time lost and forgotten. (Courtesy Lallie Hayes.)

A child's tricycle and old fishing reel come to light atop the parched earth, a remembrance of youthful days at play along Lake Avondale's shore.

A mud-encrusted wagon wheel, old and weathered, sparks images of horse and buggy days, mules and wagons, and hard labor.

An old wooden boat has come to its final resting place.

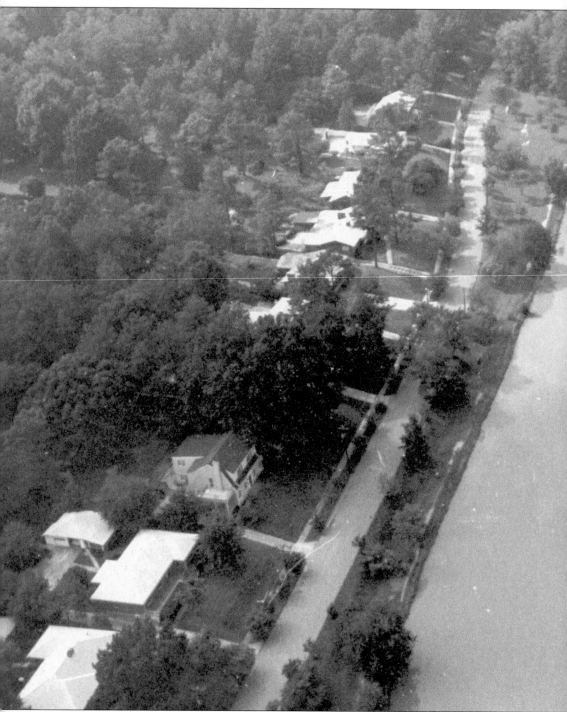

"In a deed from Mr. Willis to Avondale Estates, it is provided that the City shall maintain the lake, so long as the springs produce sufficient water to carry the lake to the proper level. When the spring water is exhausted, the lake will be drained and converted into a public park, maintained by the City. Upon the City's failure to comply with these conditions, the title to all

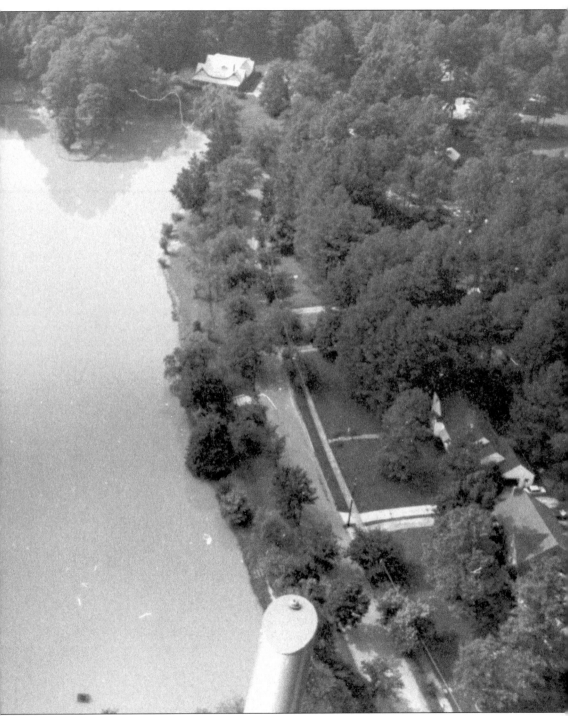

land now known as the lake property, shall revert to the Willis Estate." George F. Willis described Lake Avondale, which he so loved, in this way: "The lake nestles in its beautiful setting, fringed with tall cedars, rhododendron, and juniper. At one end, a green peninsula, clad in majestic trees, juts into the water." (Courtesy Avondale Estates Garden Club.)

Dedication

This book is dedicated to Founder George Francis Willis and his descendants, the community-spirited citizens of Avondale Estates, and to the author's parents, Harold and Lurtie Martin, for sharing their personal histories with five children, providing each one with deep-seated roots and wings with which to fly.

Acknowledgments

One is at a loss for words to find just the right expression of thanks to everyone who made this book possible. The author's sincere appreciation is extended to a few special people and organizations. During the research phase, the author could not have found more credible individuals than Thomas F. Forkner and Marion C. Reinhardt, whose knowledge and photographic collections brought the rich history of Avondale Estates to life. Special thanks are also extended to Lee and Milton Shelnutt, whose roots in the city date back to the early 1900s. The author is also grateful to each individual citizen who entrusted precious photographs, and shared their love of the city and valuable knowledge, including Maurie Van Buren, architectural historian. As a society, and personally, we are grateful to individuals who recognize the need to preserve records. Well-deserved thanks go to Reeves Studio and Guy Hayes for their diligence and artistry in photographing the development of Avondale Estates, and to Arcadia Publishing for presenting this collective history. The members of the Avondale Estates Garden Club are recognized for their care in preserving newspaper coverage of the city and its people. Throughout this process, the City of Avondale Estates has opened its doors, and special thanks are extended to Mayor John Lawson for permission granted, and City Clerk, Lyda Steadman. By nature, this book is confined to historic photographs, however, the author wishes to acknowledge "one of nature's noble ladies," Jeanette O. Farrar, who served for 19 years at City Hall, wearing many hats. The historic photographs of George F. Willis would not have been possible without the generosity of the Special Collections Department, Robert W. Woodruff Library, Emory University, and the guidance offered by the Georgia Department of Archives, DeKalb Historical Society, and Pitts Theology Library. The author also extends deep appreciation to George F. Willis, III, for his support in the publication of this book. Although Founder, George F. Willis, corrected reporters who referred to his vision of an ideal city as being a dream, after turning the pages of this book one is inspired to believe that dreams *do* come true. With that thought, sincere heartfelt thanks are extended to Anthony J. Hart for his technological support, artistic eye, and constant source of encouragement.

Newspapers and Magazines: *Hearst's Sunday American*, *The New York Herald*, *The Atlanta Journal and Constitution*, *Stone Mountain Magazine*, *Country Homes Magazine*, *DeKalb New Era*, *DeKalb Sun News*, and *The Community Review*.

About the Author: Terry Martin-Hart moved to Avondale Estates from Laguna Beach, California, where she was a travel writer and public relations specialist for ten years. Among her clients were the Nautical Heritage Museum, as publicist documenting the historic creation of California's Official State Tallship; the Orange County Marine Institute; Irvine Meadows Amphitheatre; Orange Coast Magazine; Palm Springs Life; Adventure Travel; and Newport Ski Company. In 1982, she received a sculpture scholarship to the Art Institute of Southern California. In Atlanta, her clients have included The Garden Club of Georgia, Peachtree Publishers, Scholars Press, and the Atlanta Chamber Players. An avid photographer, she has traveled extensively throughout the United States and Europe, and is a member of the National Trust for Historic Preservation.